The Modern Flower Painter

Creating Vibrant Botanical Portraits in Watercolour

Dedication

For Mum, who nurtured a garden of beautiful flowers as well as me; for Dad, who opened my eyes and taught me perspective; for Phil, who warmly helps me keep perspective every day; and to them all for oodles of kindness, love and encouragement always.

The Modern Flower Painter

Creating Vibrant Botanical Portraits in Watercolour

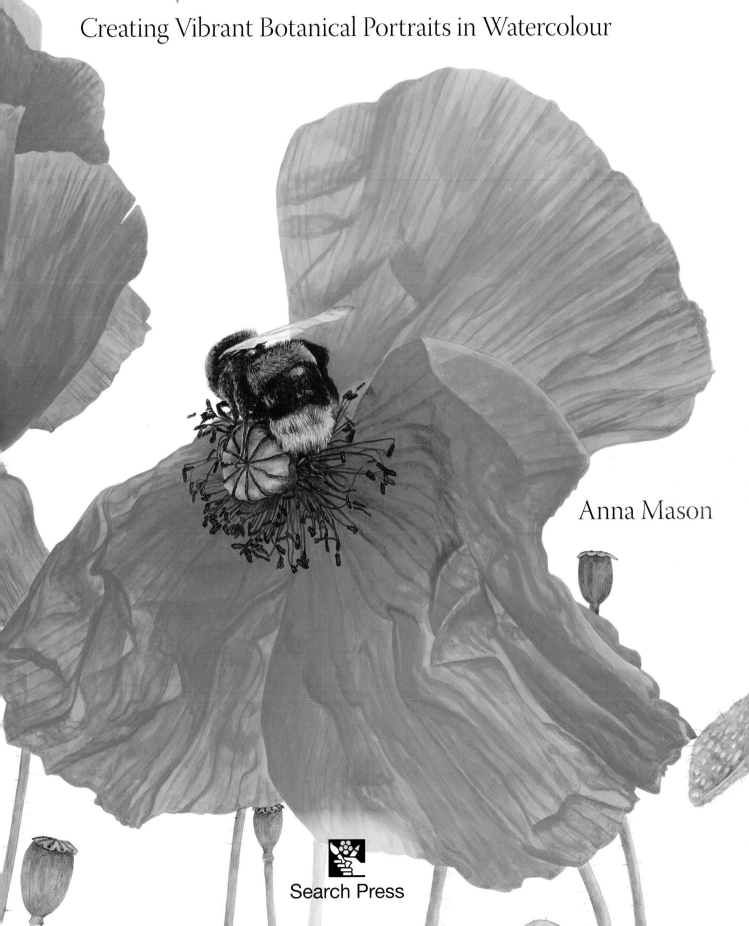

Anna Mason

Search Press

First published in 2014

Search Press Limited
Wellwood, North Farm Road,
Tunbridge Wells, Kent TN2 3DR

Reprinted 2014, 2016, 2017

Text copyright © Anna Mason 2014

Photographs by Roddy Paine Photographic Studios.
Photographs and design copyright ©
Search Press Ltd 2014

ISBN: 978-1-84448-863-6

The Publishers and author can accept no
responsibility for any consequences arising
from the information, advice or instructions
given in this publication.

Suppliers
For details of suppliers, please visit the
Search Press website: searchpress.com.

If you would like to watch video demonstrations of
technique, receive support and personal feedback,
as well as share your experience of learning to
paint in this style, you are invited to join Anna's
online class and community via her website:
annamasonart.com

Publisher's note
All the step-by-step photographs in this book
feature the author, Anna Mason, demonstrating
watercolour painting. No models have been used.

Printed in Malaysia by Times Offset (M) Sdn. Bhd.

Acknowledgments
With thanks to the team at Search Press.
In particular to Edd, Juan and Gavin for
their valued creative input in bringing this
together, and to Roz who planted the seed
of the idea in the first place.

Page 1
Vale End Rose
*A soft and intricate group of blooms which smelled as
beautiful as they looked.*

Page 3
Poppy Pollination
*A group of glorious field poppies with a bee caught in
the act of pollinating them.*

Opposite (bottom)
Rhododendron
*A delicate bloom I noticed on a lovely weekend in the
Cotswolds with my wonderful mum.*

Contents

Introduction

If you are reading this I am sure you are inspired by the natural world around you. For me, the impulse to paint a flower portrait usually starts when I notice and appreciate a flower; perhaps the rose in my garden whose vivid colour sings for attention, or the stunning blossom in the park whose appearance reminds me of the promise of summer around the corner...

From this appreciation we feel inspired to paint – to capture on paper something lasting of the beauty we see, to enjoy the process of painting, and to enjoy the picture we create as the result.

Working in a realistic style, we aim to faithfully recreate the beauty that we perceive. This includes accurate levels of detail, true-to-life depth of colour and naturalistic compositions in order to create a painting as vibrant and alive as the flower before us. In order to do this, we need to use our visual perception in a slightly different way from the way we use it in daily life, so that we can really 'see' all that we need to capture on paper.

In this book I cover the watercolour techniques I use to recreate all the colour and detail we see in our subjects, and also aim to help you make the shift into 'seeing' all that you need in order to achieve realistic results. Making this shift is the most important thing. The book shows you my specific technique of painting, which is by no means the only one. In fact, every artist works with paint in a slightly different way. There are only a few real 'rules' of watercolour painting (which I will of course cover in this book) and, once you have learnt to see what is in front of you, the way is open for you to play, to discover what gets the best results for you and – most importantly – to find what you enjoy the most.

I know that if you are relatively new to watercolour, it can be a daunting medium and so this book shows you my technique in considerable detail. Showing you exactly how I use watercolour will help you to gain confidence with the medium, which in turn should allow you to really enjoy the process of painting.

Through teaching this approach at workshops and online, I know it gets great results. In addition, while results are really important, it is equally important that the process of learning to paint is enjoyable too. Some beginners are so keen to produce work they will be happy to frame and hang on the wall that they put an enormous pressure on themselves to create masterpieces straight away. With that attitude, it is not really surprising when they find the process of learning to paint stressful and far from the relaxing hobby they had hoped for. The best thing you can do in your development as a painter is not to put that kind of pressure on yourself. Instead, relax and remember that no one can produce perfect results immediately. Even with the instructions I am offering you here, practice is invaluable and should be fun. Please be kind to yourself! Give yourself a chance!

In that spirit, I hope this book can be a manual on technique, a source of inspiration and also the voice of kindness, encouraging you to keep practising so that you too can enjoy painting to the full.

If you would like to watch video demonstrations of technique, receive support and personal feedback, and also show me your own attempts at the projects in this book, please check out my online lessons and community via my website: annamasonart.com.

Wishing you lots of fun!

Anna

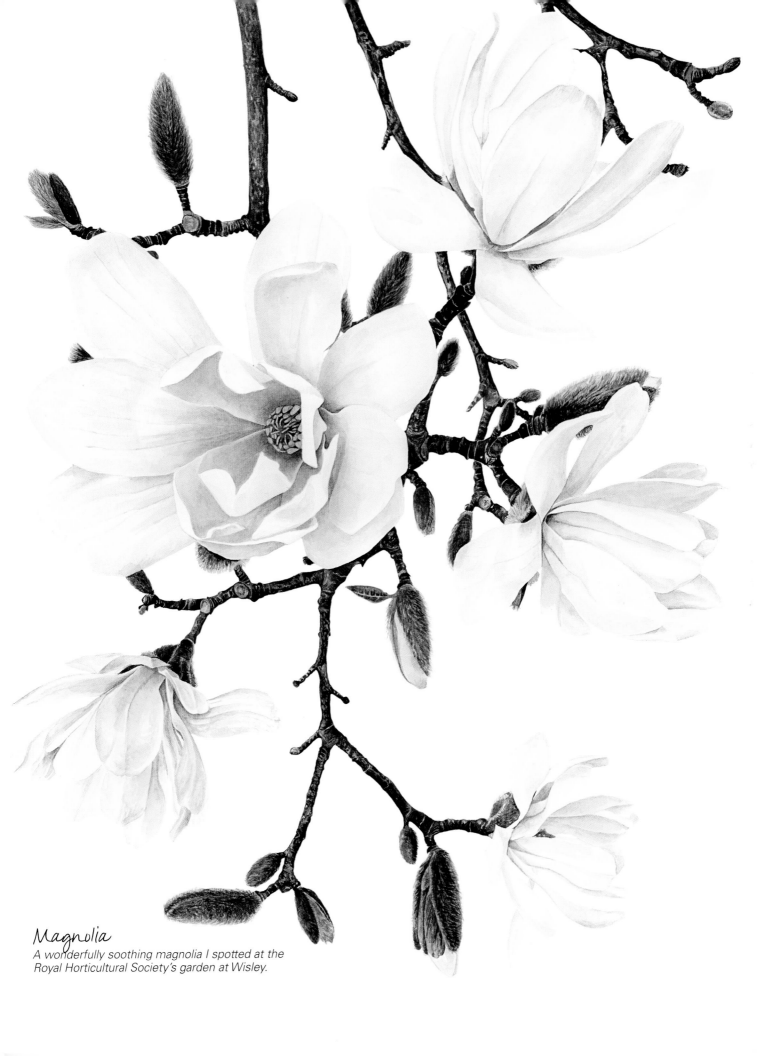

Magnolia

A wonderfully soothing magnolia I spotted at the Royal Horticultural Society's garden at Wisley.

About the author

I have always enjoyed creating pictures. As a child I was lucky enough to have this enthusiasm encouraged by my parents, with the result that I spent thousands of hours practising – or playing, as it really was. Although I never painted the kind of detailed work I do now, all that practice honed my ability to really 'see' in the artistic way.

After I left school, I had a big break from doing any artwork, taking the so-called sensible option of pursuing a career in local government management. I missed painting and when I stumbled across botanical artwork for the first time in 2006, I immediately knew I had found what I should be doing.

My flower portraits

Traditional botanical illustrations are created in order to depict botanical subjects for scientific identification. For me, however, painting flowers in a realistic style is about showing off the exquisite detail that flowers contain for purely aesthetic reasons. To do this, I work totally accurately, with as much detail as I can reproduce, and with bright bold colours that are true to life. I do stick to the botanical illustration tradition of having no background as it allows for total focus on the subject. Where I differ in style from botanical illustration is that I like to work larger than life for visual impact and capturing detail.

The other way my paintings differ from botanical illustration is in my choice of composition. I use composition to capture something of the essence of the flower – reflecting through the painting the beauty I saw in the flower itself. This helps to create a more personal response and a portrait of that flower.

My approach

Coming to this style of work completely fresh, as I did, meant finding out for myself the best, most practical way of working. This involves taking and using photographs as my main visual references from which to work, so that I can paint whenever it suits me. With all the detail I capture, the paintings can take from a few days to a few weeks to complete, so this practical approach is really important. When I began, painting was something I fitted around my full-time job, catching half an hour here or there to paint, so this flexible technique will allow you to work in shorter or longer periods of time to best suit you personally.

Ultimately my approach is about optimum enjoyment of the process of painting. It is about relaxing and having fun so that the process of creating the painting is just as important as the final result.

How to use this book

The first part of the book serves as a manual on my technique. It covers everything from the materials I suggest you use, right through to understanding the importance of tone, how to mix colours, and how to apply the paint. I have tried to make it suitable for everyone: even those new to watercolour.

I have also broken down my process of painting into six main stages and I demonstrate those stages through painting a rose. I suggest you experiment with your watercolours a bit, if you are brand new to them, and that you then try this rose step-by-step as your first go at painting in this style.

The second part of the book has six step-by-step painting projects to follow, where I detail everything I do, with reference to the different techniques covered in the first part of the book. They are laid out in order of difficulty so I suggest you try them in that order to get the most from the book. Also, do have a go at them several times if you think you can improve – it is all great practice!

I feel so lucky to be able to use my talent and it is my privilege to help you to tap into yours.

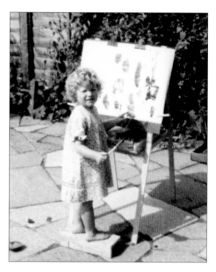

Me 'practising' (playing!) aged two years and two months.

Opposite
Apple Blossom 'James Grieve'
This is an early painting of the tree in my garden.

8

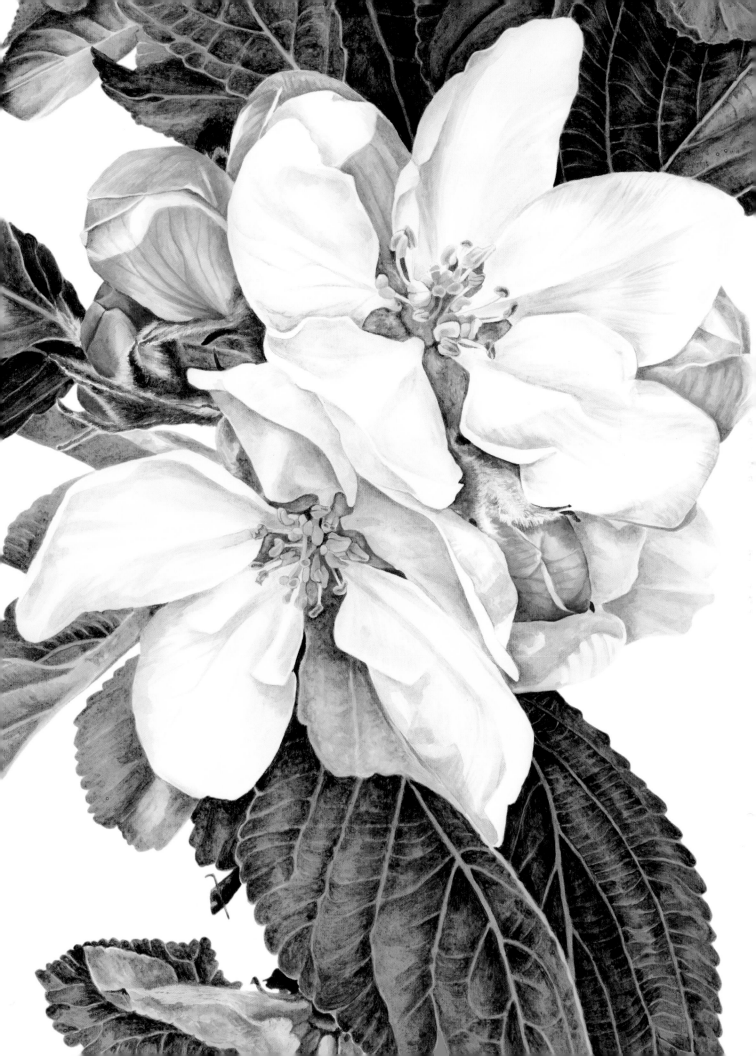

Materials

The materials I now use are based on trial and error since I started painting in this style. They are always evolving. Since I have been teaching, students have introduced me to new brushes and colours which I have gladly tried and found to be improvements on those I was using before.

As a result, the information on these pages is by no means entirely definitive, but it will give you the key points about what you should have in your kit before you get started.

Watercolour paints

I love watercolours. They are the most practical of paints. They are odourless and it does not matter if they dry out – so they are perfect for leaving out, set up and ready, all the time. They make catching thirty minutes of painting time here or there as easy as possible, which is important for fitting into our busy lives.

It is great if you are lucky enough to have a dedicated desk or table for them so can leave them out all the time, but if you do not, their small scale means getting them out and clearing them away could not be easier.

Brilliance of colour and transparency are the two main features that I look for in my paints. 'Brilliance' can be defined as the richness, intensity and depth of colour of a paint, while transparency refers to the quality that leads to being able to build up the gradual subtle washes that are a vital part of my technique.

Quality

The better the quality of the pigments, the more brilliant the results. The best pigments are used in professional or Artists' quality watercolours. The actual colours I use are detailed on pages 38–39.

Students' quality paints are not as brilliant as Artists' quality and they are also less transparent. If you already have these, do not be deterred from having a go with them, but be aware that you will not be able to get the brilliance and transparency required to accurately reproduce the colours in many flowers. If you can, treat yourself to a professional or Artists' set – it will make all the difference to your paintings.

Watercolours take up little space and are very portable. All of my paints fit into just one small tin.

Pans versus tubes

I prefer to use pans as I like to be able to see all of my colours laid out in front of me when I am painting. This way I never have to interrupt the flow of painting to stop and squeeze out some of the colour I need next. I also like how dry the paint is in a pan as it produces the thickest, darkest version of the colour – which is often very useful for the darkest areas of a painting.

It is true that using pans is tougher on your brushes because the paint is harder, but I think it is a price worth paying (see page 13). If you do use tubes, I would recommend squeezing paint out from them into empty pan cases, which are sold at art shops. Once dried, these will then behave exactly the same as bought pans and means you will always have all your colours immediately ready to use when painting.

Characteristics

Watercolour paints are made by combining or suspending a pigment with some sort of binder, to create a paint that stains the paper it is applied to. It is the properties of the different pigments that give different watercolour paints their individual characteristics. These properties are not always obvious: in the pan, two paints can appear virtually the same despite their different properties.

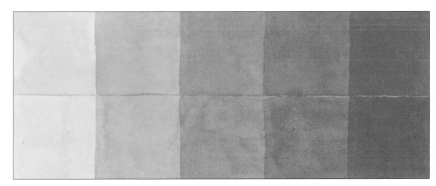

In this example, you can see a row of opaque cadmium red on top and its transparent counterpart, scarlet lake, on the bottom. Layers have been built up in each row from left to right; a single layer of the colour on the leftmost squares, and five layers on the rightmost squares.

The difference is subtle, but the cadmium red appears more dull, particularly when applied in thin, watery layers, which is key to my technique.

Tip

If you are using tubes, always squeeze the paint out so that the paint can be used for more than one painting (which is why I suggest an empty pan case). You will usually find you only use a tiny amount of paint for any one painting with this style of work. Unlike with oils, there is no problem with letting watercolour paint dry out, so do not feel compelled to clean it away when you think it is drying.

Palette

When I began painting, I bought a set of Winsor & Newton paints that came in a quality enamelled tin, which can be used as a palette and mixing tray. I still use that same tin now. I have also found using a white china plate works well.

China and enamel provide surfaces that do not easily stain and are flat, allowing the paint to spread out really thinly so that you can clearly see the consistency, and therefore judge how the paint will look when you apply it to the paper. For this reason I would suggest you steer clear of any type of palette where you end up with a pool of paint, as you will not be able to accurately assess how dark the colour you are mixing will appear once it is spread thinly on the paper.

Cheaper plastic palettes stain really easily and the paint seems to want to clump together on them rather than spread out, and so they are best avoided for this type of work.

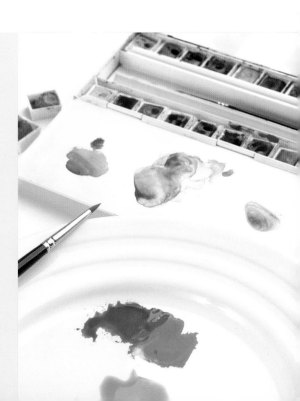

Paintbrushes

In the first few paintings I produced in this style, I experimented with many different brushes. Finding the right ones had a significant impact on the quality of what I could produce. I wanted control over the marks I was making as well as a brush that could carry a decent quantity of paint. Getting the right brushes is essential to being able to produce the kind of quality work you want.

Quality

I always use kolinsky sable brushes. They are the best, and you can really feel the difference. They hold a good quantity of paint meaning you do not have to reload your brush with paint as frequently. Although they are amongst the most expensive sort of brushes, they should last you quite a long time, and at the small sizes I use, they are actually quite reasonable.

Shape

For this style of painting I use miniature or spotter brushes. They are shaped like a tear drop which means that they are able to hold plenty of paint at their base and yet also have a sharp point, meaning that you can create really crisp lines. They also lend themselves perfectly to the stippling technique I use so much (see page 51 for more information on stippling).

Their bristles are shorter than most watercolour brushes and this gives you a greater feeling of control over the marks you are making. I often think that they feel like using a felt tip pen – something I loved as a child!

The brand I favour is series 323 from Rosemary & Co. They are a UK-based manufacturer who produces an excellent 'Anna Mason' set of the five sizes I recommend. Winsor & Newton's Series 7 Miniatures are a good alternative that share many of the same qualities.

Sizes

I always work with fairly small bushes. Brushes are given numbers to indicate their size, but these can vary quite a bit between brands. The following are based on Rosemary & Co or Winsor & Newton Series 7 miniatures and the picture in the box to the right gives you an idea of their sizes, should you need to compare them to those you already own.

Although I own a size 8 I would only ever use that on the first, most watery wash of a very large painting. The largest size I regularly use is a 5, and I most often use sizes 3, 1, 0 and 000 (sometimes shown on the brushes as 3/0). I do not usually bother with an 00 (or 2/0) brush as it is so close to a 000 in size. It is possible to create most marks with the five brushes listed above, so I would recommend getting those when you begin.

why small brushes?

Sticking to small brushes means there is less likelihood of getting too much paint on the brush at one time. This helps to maintain quick drying times, and better control of the paint. I use the larger size 5 brush only on larger paintings or initial washes of large blocks of colour.

My brushes. From top to bottom: sizes 5, 3, 1, 0 and 000.

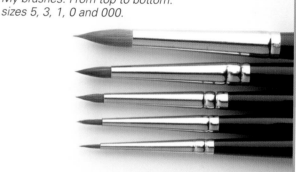

A carry case is vital to keep your brushes safe and secure when you are on the road.

Storage of your brushes

Paintbrushes are quite delicate and so it is really important that you do not leave them standing tip-down in your water pot – or anywhere else! If you accidentally do that, you will find that the bristles quickly bend out of shape and it is tricky to get them to go back. I have been told that hair gel can be used to set them back in place should this happen to you, but try to avoid the situation in the first place.

Always store your brushes tip-side up or on their side. When I am on the move, I use a carry case with elastic holders that keep the brushes in place, while in the studio I use a brush tree which allows me to see exactly where the brushes are. In reality though, I am quite messy and they often end up lying on their side on my desk.

Care of your brushes

Aside from making sure they are stored properly, I do not do anything to care for my brushes. I only ever wash them in water – and usually that is just in the water pot as I am painting, rather than at the sink afterwards.

Using such small brushes on hard paint pans wears them down quickly and means I do get through quite a lot of the smallest size brushes. I tend to replace them after about two or three large paintings, but as they cost about the same price as the paper I just consider that one of the costs of producing a painting.

Brushes get washed as I paint to keep them clean and prevent paint building up on the bristles.

A brush tree, in which your brushes can stand, is a useful addition to your painting kit.

Watercolour paper

It is really important to have a good quality paper. The properties I look for in a paper are:

- **Smooth texture** Smooth watercolour paper is called Hot Pressed or HP, and a smooth texture to the paper means that you will be able to achieve really crisp lines and create areas which look really smooth. Watercolour paper also comes in Not (short for 'not Hot Pressed') and Rough finishes. Both have a bumpy texture designed for much wetter and looser painting.

- **Weight** The paper needs to be thick enough that it will not cockle too much (i.e. wrinkle) as you paint on it. Although I do use very watery paint, and usually begin by laying down an initial thin wash across most of the subject, I do not use large volumes of wet paint at any one time. Therefore I am able to use 300gsm (140lb) paper and never need to stretch my paper.

- **100 per cent cotton** A quality watercolour paper is made of cotton rather than the wood pulp of standard paper and is significantly more absorbent as a result. That is particularly important with my style of work, where each layer of paint needs to dry before the next is applied.

- **Acid-free** Quality paper will be acid-free and therefore will not yellow with time.

- **Whiteness** Most watercolour papers are a little creamy but if you compare them in an art shop you will see that there is variation. As we are using the white of the paper to shine through our paint and provide luminescence, it is really important that the paper is as white as possible.

- **Glued to a block** I prefer to work on paper that is glued on all four sides on to a block. It has the effect of keeping the paper taut and deterring cockling when applying washes.

Having tried most papers, I prefer Arches Aquarelle Hot Pressed watercolour blocks. They are exceptionally smooth and as white as the whitest papers. They also produce blocks up to 46 x 61cm (18 x 24in) which I like to use. For larger work I do sometimes use illustration board. I enjoy working on it as it is ultra smooth and white but I do not recommend using it until you are really comfortable working in this style, as it is much less absorbent.

For the projects in this book, you will want a Hot Pressed watercolour paper 18 x 26cm (7 x 10in) in size.

Watercolour painting blocks come in a variety of sizes.

Other materials

Pencil For the drawing we are aiming to produce a fine, clear but fairly light outline drawing that is easy to erase. An HB is ideal and it needs to be really sharp to give you a very fine line. So I use a mechanical pencil with a 0.5mm (1/32in) HB lead as it means you never have to sharpen it!

Easel It is much more comfortable to paint for extended periods when using a table-top easel as you can angle your painting so that you do not need to hunch over it. Most table top easels only have a few angles that you can set them at. However, I use a Daler Rowney Art Sphere, which can be adjusted to any angle, ensuring you can get just the right angle for your comfort. Bear in mind you do not want the easel so upright that the paint starts to run.

Daylight lamp This style of painting takes time, and on a winter's day we want the flexibility to be able to work on into the evening. To make sure we get colour accuracy we need to use a special full spectrum light bulb or tube which replicates the white colour of natural light, rather than the yellow light of most regular light bulbs or tubes. I use full spectrum fluorescent tubes in an angle-poise lamp to light my workspace and this works really well.

Eraser I use a quality plastic eraser and it always gets a really clean result. Steer clear of putty erasers as they can be quite messy and mark your paper.

Ruler or **tracing paper** This is essential for creating a really accurate drawing when working from a photograph.

Water pot I use a clear drinking glass or jar so that I can keep an eye on the colour of the water and decide when it has got too much paint in it and needs changing.

Computer or **tablet** Because I prefer to work from photographs, it really does help to be able to view those photographs on a decent quality computer screen, rather than having to print them off. Printing photographs from a household printer usually reproduces colour poorly.

Digital camera Even the most basic digital cameras these days comes with a macro setting (usually depicted with a flower symbol) which is really useful for this style of work. It is also worth buying a spare battery for it as it can be very frustrating to run out of power just as you are photographing the most stunning flower out on location.

White card For positioning behind your subject as you photograph it, this is the ideal aid to composition. I use a large piece of plasticard as it is waterproof and you can wipe pollen off it. It is available in art and craft shops.

Palette knife To release a finishing painting from a paper block, you need to slide a palette knife into the gap in the glue and slide it around to release the sheet.

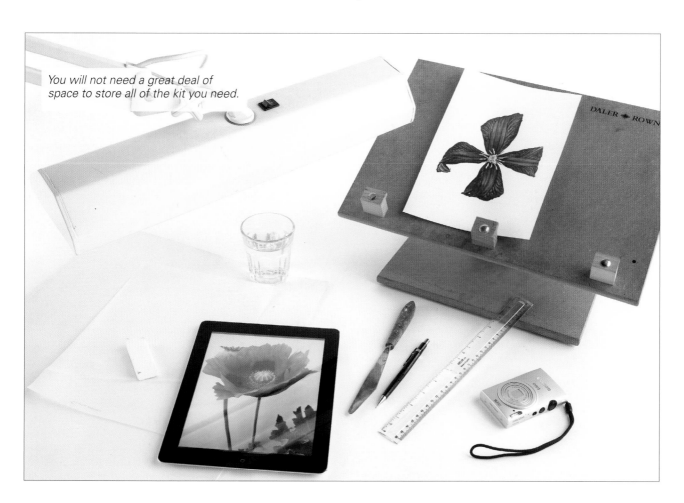

You will not need a great deal of space to store all of the kit you need.

Getting started

Once you have all the materials you need, you will need something to paint! In this section I show you how to gather excellent reference material that will mean you can paint whenever you fancy it. Once you have your reference material sorted, I show you how to set up your workspace so that you are ready to begin.

The final stage of preparation for painting is the drawing. Accurate drawing is really important to get right for this way of working, so I show you step-by-step how I tackle drawing, including how to scale up from your reference material should you want to. Accurate drawings do take time, but here I want to simplify this process for you so that you can get painting as quickly as possible.

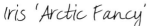

Iris 'Arctic Fancy'
I spotted this while on a photography trip to the Royal Horticultural Society's garden at Wisley. It was not very tall, so I had to lie down next to it to get the photograph from which to work!

Reference material

Digital photographs

By far my main source of reference material is digital photographs that I have taken myself. Traditionally, botanical artists have painted their subjects from life. If that is how you prefer to work, that is fine and the painting technique can also be applied to painting from life.

However, working at a larger than life scale means my largest paintings take up to three or four weeks to complete when painting for several hours a day. It would be completely impractical to try to paint from life, as very few botanical subjects would last that long. While it used to be the case that standard cameras would struggle to capture the colour and detail required for this style of painting, the same cannot be said of modern digital cameras, whose quality is excellent and improving all the time.

Even the most basic modern digital cameras – which you may already own – can take very high quality photographs when used properly (it is worth reading the manual). There is the added advantage that you can take dozens of photographs, view them straight away and then simply delete the ones that you do not want to use. You can also view photographs on your computer screen, rather than print them off – as mentioned previously, with most computer screens that means you will see more accurate colours from which to work.

Photographs also have the advantage that they allow you to capture an image of the flower showing where and how it was growing. Working from life means you often have to contend with the lighting of your subject changing, whereas photographs allow you capture how light was falling on a subject in a moment in time, which makes it significantly easier to reproduce it accurately. With the emphasis I place on light and dark in my painting, this is so important for great results.

Photographs also free you to be able to paint summer flowers in the depths of winter. They really put you in control.

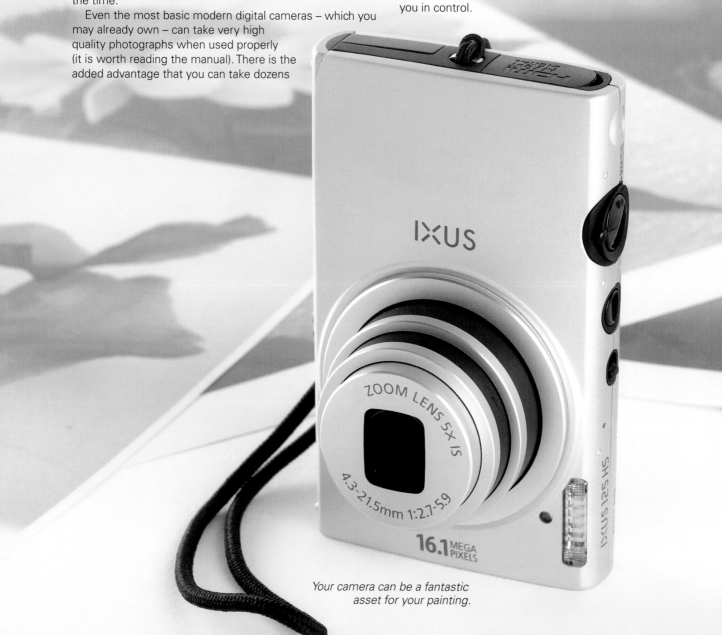

Your camera can be a fantastic asset for your painting.

Composing with your camera

My creative process starts with taking photographs of flowers that inspire me.
Usually this is on a trip to a garden – either my own, a friend's or a public garden.
Ideally you want a day when the light is good: really bright but not so sunny as to
cast strong shadows.

Once I spot a flower I like, I isolate it using a white piece of plasticard
positioned behind it and move the camera – and myself – so that I get the angle
that looks best to me. What I then see on the camera's viewfinder immediately
looks like a possible future painting. As I like to work on watercolour blocks it
also works very nicely that the aspect ratio (the proportions of the viewfinder)
are almost exactly the same as the aspect ratio of the watercolour paper.

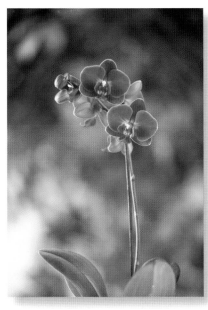

*It is much easier to imagine
your subject as a painting when
you photograph it against a
white background (right). A white
background also makes it easier to
assess the colour of the subject.*

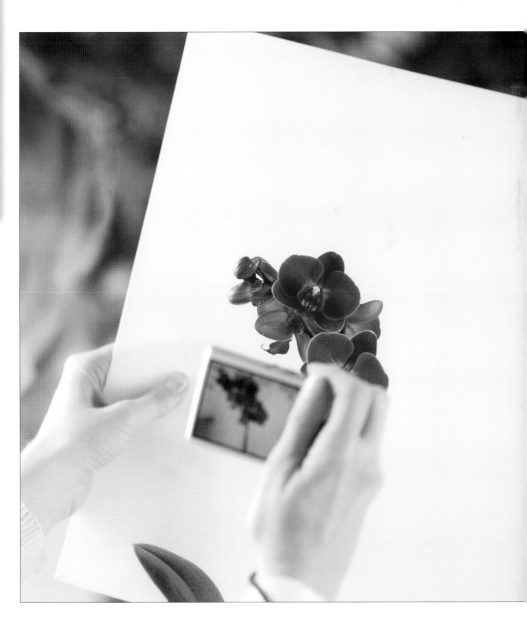

Capturing details

Once I have a photographic composition that 'clicks', I also take a series of close-up (macro) shots of all parts of the flower. I can then use all the photographs as well as my notes to refer to when I come to draw and paint my finished flower.

Working shots and notes

I check my photographs on the camera as I go along. It is usually obvious from a quick look at the viewfinder whether the camera has reproduced the colour well or not. When I paint from my photographs, I view them on a computer screen that I know reproduces the colours really well too, so because of this I am usually confident to work purely from my photographs.

 The camera can occasionally struggle to accurately capture some very vivid reds and purples. With my set up, I only take colour notes for these subjects. However, if you are going to work from prints of your photographs, or if the computer screen you will view them on is not colour accurate, then you will very likely want to take some colour notes too to refer to along with your printed photograph, to help you with matching the colours when you paint.

Note

The macro function for most cameras can be activated by pressing the flower symbol. Some activate automatically when you get your camera to focus very close to your subject.

Tip

Remember to write down exactly what paints you used to mix the right colours. If you do not, you are likely to forget!

When you take a photograph to set up your composition, it is likely that only one area of the composition is fully in focus. This is especially likely if the subject has a lot of depth to it. After I have taken the composition shot, I turn on the macro function and photograph every element of the composition in turn, checking in the viewfinder that they are in focus before moving on.

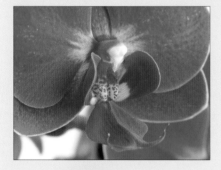

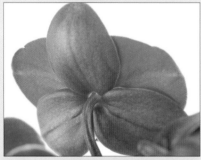
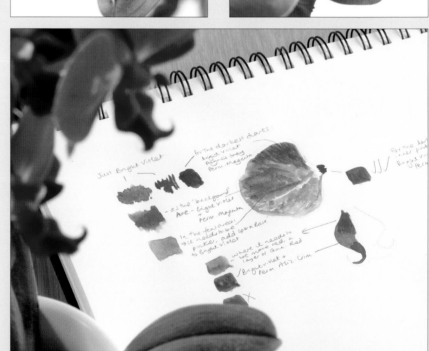

Setting up your workspace

Having taken your photographs and made any colour notes, you will need to either print out your photographs or get them on to your computer or tablet, ready to begin work

 You will want your paints and water set up to your side (to your right if you are right-handed, or to the left if you are left-handed). You will also want good lighting, but you can ensure you have this by using a daylight lamp.

 Have your reference material – printed photograph, computer screen or tablet, or even the plant itself – nearby when painting for easy reference. When you are working on the projects in this book you will want the book close to hand.

 Watercolours are so practical as they take up very little space. If you can find space in your home to leave your workspace set up, then that is ideal as it means it is that much easier to spend thirty minutes or an hour painting whenever you get the chance.

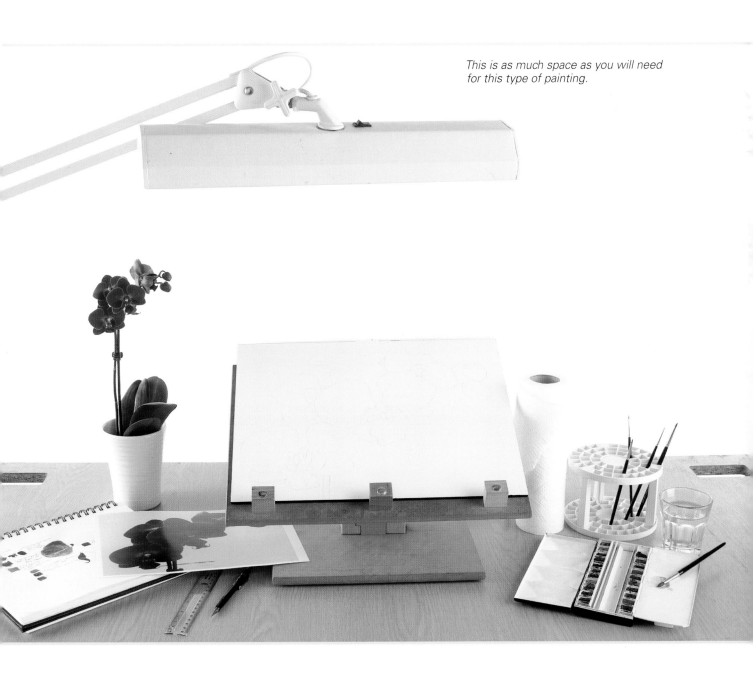

This is as much space as you will need for this type of painting.

Drawing

Your drawing is the foundation for your painting: a guide for where to apply the paint. Having a really accurate drawing will make the process of painting in this style a pleasurable flow. Personally, it is my least favourite part of the whole process, but I have learned the hard way that it is not worth rushing the drawing stage, as it is so important to the painting.

Deciding on a scale

Having taken a photograph of a composition I am excited to paint, I next decide on a scale for the finished piece. Usually I will visualise the image and get a sense of what size it would work well at and – importantly – how large I would like to paint it. Generally speaking, the more detail I have captured in the reference photograph, the larger I would prefer to work – up to about 75 x 50cm (30 x 20in). I would work larger still if I found a comfortable way to do it!

The reason I like working large is that the final painting then has great impact. It can command attention from the other side of the room, and invite people over to study the detail. It also helps with giving the viewer the sense that they are 'up close and personal' with the flower, allowing them to see the detail in nature that they do not normally notice.

I am often asked whether working so large is 'allowed' within botanical art traditions. The answer is that if you had been commissioned by a scientific institution to paint a specific plant for identification purposes, then the convention is that you would depict it life-size. However, we are painting purely for aesthetics, so we do not have to concern ourselves with those requirements. The Royal Horticultural Society, who judge botanical art, are quite clear that paintings they judge meet their standards of botanical accuracy so long as the scale is stated. I am proof of that, as I won a Gold Medal with them in 2007 for some much larger-than-life paintings.

Larger than life

To scale up, I decide at what size I would like to paint the subject, based on the paper I would like to work on. If you are viewing your composition shot on a computer screen, or even if you plan to print it off, I suggest that you use photo-editing software to re-size the photograph to the size you want to paint it. If you want to print and you can not print it large enough, you will need to print it as large as you can and work out what the scale of your print-out is compared to your watercolour paper. You can then use this scale and apply it to any measurements you take to increase your drawing in proportion.

Making a line drawing

As the first stage in the creation of a painting, I produce the drawing as a guide to where I should be applying the paint. As such I aim to produce a very accurate line drawing. It is not simply the outline of the main compositional elements, but the outline of the key details within them.

We do not want the drawing to be visible at the end, so the line needs to be nice and crisp but also light enough that it does not stand out too much once the watercolour is applied. This becomes even more important for very light flowers. Related to this point, we do not want to produce a tonal drawing where we mark in shade. We will create all of our tone using paint later on.

Accuracy

When you are painting you will be making visual comparisons back and forth between your painting and your subject. Those comparisons are made much easier if your drawing is really accurate. Conversely, if you have an error in your drawing, that flow is interrupted as you have to keep making adjustments based on the difference in your drawing, and therefore you are not actually painting exactly what you see. It is for this reason that it is important to get your drawing as accurate as possible. To achieve accuracy I always take lots of measurements as I work.

If you plan to paint from a photograph on-screen, you can also use the photo-editing software's guides and rulers to easily take measurements of key compositional points. If you do not have access to a computer, then you can enlarge a photograph to the correct size on most photocopiers. Alternatively, you can decide the scale by which you want to enlarge and multiply any measurements you take by that number.

Tip
You will make lots of mistakes with your drawing. I do all the time. Let me reassure you – you can make extensive use of your eraser without it marking your paper so long as you are using a quality paper and you use a plastic eraser fairly gently. Because of this, I always draw directly on to the watercolour paper.

An outline drawing of the compositional elements of an orchid.

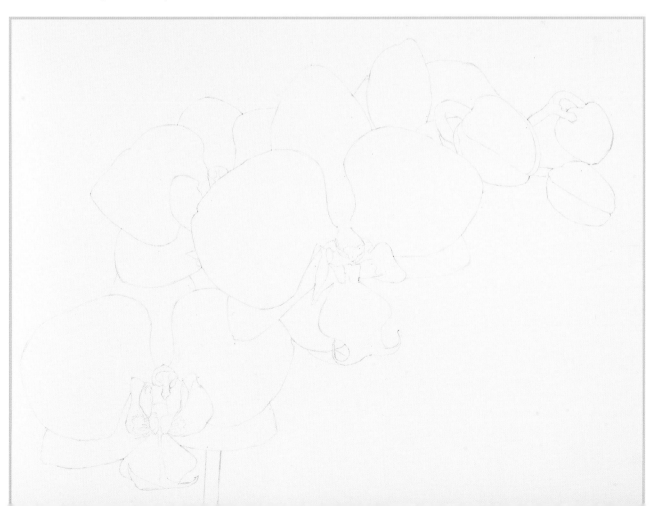

Drawing for the projects in this book

Because the focus of this book is to develop your watercolour skills, I have included outlines of the painting projects in the back of the book for you to trace if you prefer. If you prefer not to trace, then you will need to take measurements with a ruler to aid your free-hand drawing. You can do this using either the finished painting of the relevant project as your reference, or the outline at the back of the book. Here I demonstrate the measuring technique using a printed photograph as my reference material.

Getting your flower on the paper

Most compositions will intersect with the outside edge of the compositional frame – in other words, part of the flower, stem or leaf will meet the edge of the reference photograph. Identifying this point will help you achieve accuracy, as for those measurements you will only need either a horizontal or a vertical measurement to get the key point in exactly the right place. Once this is achieved, you can use this point as a reference for getting the rest of the drawing accurate.

1 Put a frame around your image using a pen or pencil, enclosing everything you want to include in the finished picture. If the image has a natural frame (such as the edge of the source photograph), you can ignore this stage.

2 Keeping the image close by for easy reference, use the HB propelling pencil to draw a very faint frame on the paper. This can be the same size as the original, or you can make it proportionally larger for a bigger finished picture.

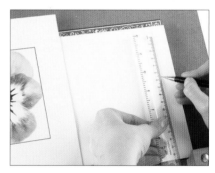

3 Identify where the composition touches the edge of the frame on the image, and use the ruler to measure to the same spot on your paper. Mark this point lightly with the pencil.

4 Use your pencil to start drawing the shapes (such as the edge of the petals) near this point, then repeat for the other points that touch the edges of the frame.

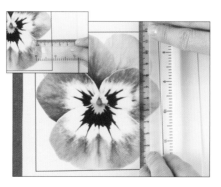

5 Identify some key points on the image, such as where the petals meet, and measure in to one of the points from the side (see inset), then down from the top.

6 Lightly mark this point on the paper and use it as a guide to draw the nearby shapes as before.

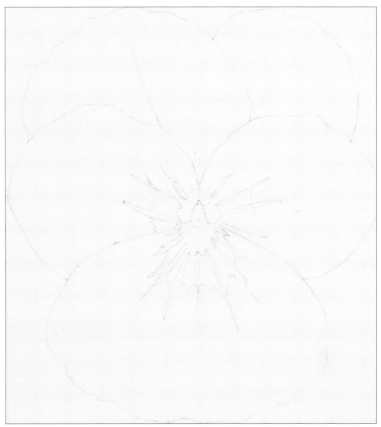

7 Identify other critical parts and mark them in very lightly. You can mark as many as you feel you need.

Tip

Use the frame to help identify negative shapes of white space around the flower. Getting these correct will help you with the positive shapes like the main petals.

8 With careful reference to the original source image, use your pencil to join the parts of the drawing already started. When judging which parts to add in, avoid outlining any parts of the flower that are lighter in tone than the pencil, as these will show through in the finished painting. In this example, I have outlined the very dark markings in the centre, but not the lighter ones on the lower petals.

Use the eraser wherever necessary while drawing out your flower. Keeping the pencil lines light means that it is easy to adjust for the most accurate finished result, as seen to the left.

Painting colour

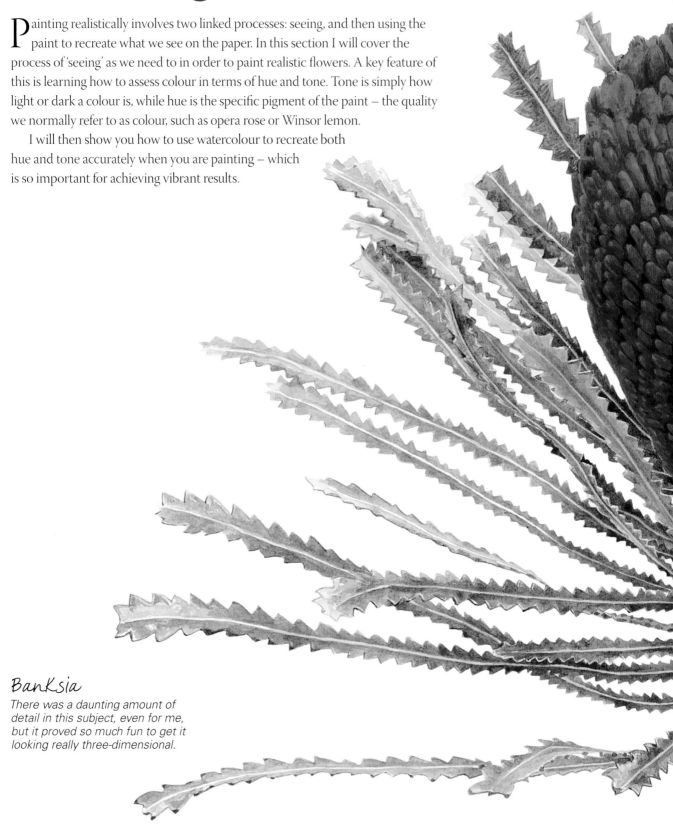

Painting realistically involves two linked processes: seeing, and then using the paint to recreate what we see on the paper. In this section I will cover the process of 'seeing' as we need to in order to paint realistic flowers. A key feature of this is learning how to assess colour in terms of hue and tone. Tone is simply how light or dark a colour is, while hue is the specific pigment of the paint – the quality we normally refer to as colour, such as opera rose or Winsor lemon.

I will then show you how to use watercolour to recreate both hue and tone accurately when you are painting – which is so important for achieving vibrant results.

Banksia
There was a daunting amount of detail in this subject, even for me, but it proved so much fun to get it looking really three-dimensional.

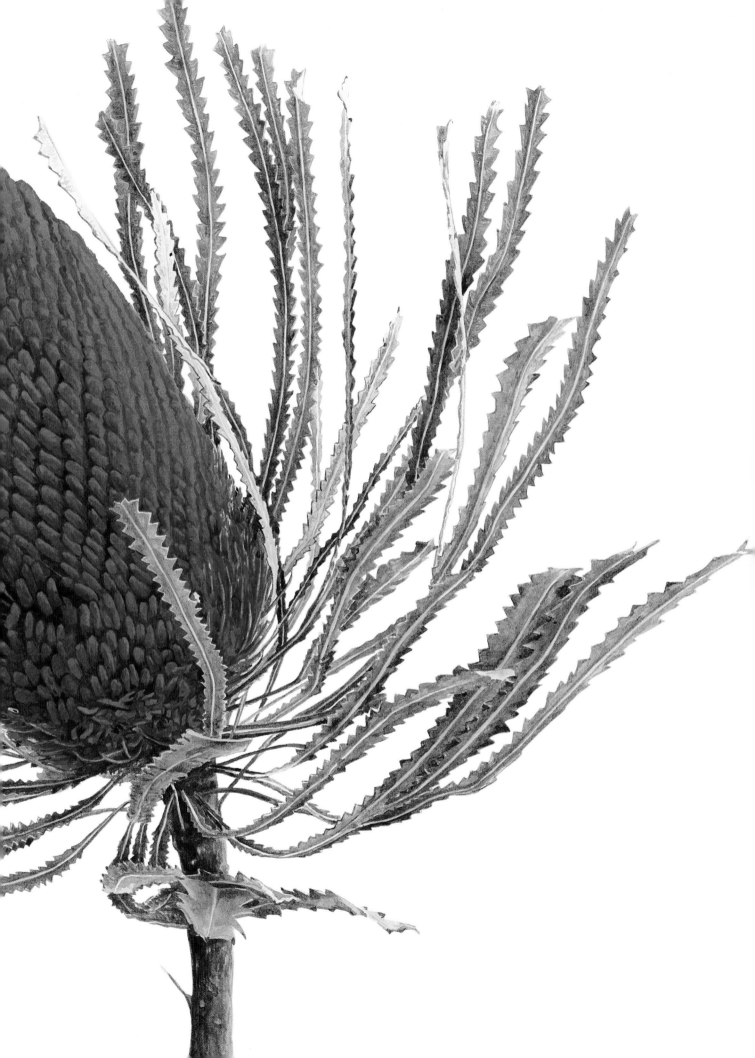

Learning to see

When we are seeing a subject, we need to look at it very closely and break it down visually into constituent shapes of colour. The analogy here is with a digital photograph that, when viewed at a high resolution, is actually a series of different coloured pixels. In order to then reproduce those colours and shapes correctly in our own painting, we need to step back (this often means literally) and assess our subject – and our painting – as a whole.

These pages use photographs of the tulip to the right to explain these aspects of training your vision as you begin to use watercolour to paint your own flowers.

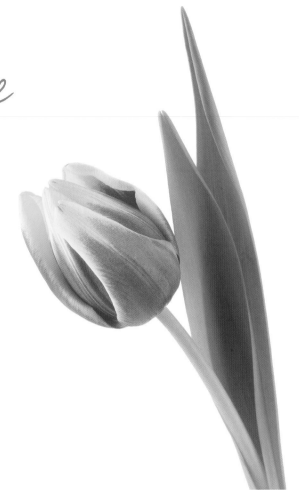

By desaturating all but the yellow hues within this tulip, the shape that the yellow hues make is emphasised.

Seeing shapes

Producing a really accurate drawing means that we can mark in a lot of the different shapes of colour before we begin to paint, making the whole process easier. I use a lot of measuring to make sure I get outline edges and similar lines in the right places. Having an accurate drawing makes it much easier to then see how the shapes of colour within the subject come together. If it is possible, I will also draw out those shapes of colour at this point.

However the shapes of colour often do not have convenient hard line edges, and our paint might be light enough that we would not want to see the pencil through it. The tulip has a graduated edge between the yellow on the edge of these petals and the red in the centre. We will not want to see the hard line edge of a pencil line under our pale yellow paint, so we will need to put these yellow colour shapes in place as we paint, without a drawing to guide us. To help us to do that, we can pay close attention to the negative shapes, or spaces between elements in our composition as we build up our layers of paint.

Seeing colour – tone and hue

Assessing colour requires close careful observation. For example, a quick look at the tulip could lead us to think that the red parts of the petal were simply one colour of red, but when we look closely (see right) we can see that it is actually made up of a lot of different shapes of slightly differing tones (the relative darkness or lightness of a colour) and hues (the specific pigment of the colour). This is another reason I prefer to work on a larger scale, as this sort of detail becomes easier to see.

Tonal range

Each hue has a different range of tones. For example, in the chart below, the darkest yellow has a lighter tone than the darkest blue. Therefore we can refer to light hues (such as yellows) and dark hues (such as blues).

Detail of the tulip petals. Note the variety of hue and tone.

Changes in tone: darker to the left, lighter to the right.

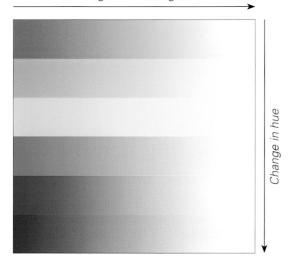

Change in hue

Colour perception

Because of the way we perceive colour, we also need to step back and assess it as part of the whole composition. Colour is relative: the way that we see the hue and the tone of an area within a subject depends very much upon the hues and tones around it and in the rest of the subject.

In the case of the tulip, to make sure that we had matched the colours in the red petals correctly in terms of hue and tone, we would need to assess them as part of the whole composition; i.e. next to the dark greens in the leaf and next to the bright yellows at the edges of the petals. This applies to both the tone, and to its hue.

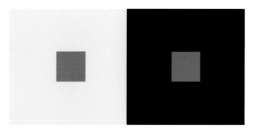

Relative tone

These green squares are exactly the same hue and tone, but the one viewed against a light tone (left) looks a lot darker than the one against the darker tone (right).

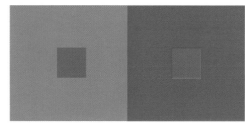

Relative hue

Here green squares are set against two different hues (blue and red) of equal tone. Against the blue, the green looks as if it has a little more yellow in it. Against the red, the green seems to have a little more blue in it.

Note

When we are matching a colour with our paint, it is potentially really tricky until we have got all of the colours in place in the painting. My method of gradually building up paint through layers allows us to adjust for tone and for hue as we go along so we can get really accurate results.

Using the 'right brain'

Through talking with students and a little research I have come to understand this shift into the artistic way of seeing as an accessing of the visual mode of perceiving information associated with the right hemisphere of the brain. This is the side which perceives patterns, shapes and the relationships between them, including how they come together to make the whole picture. It is your right brain that will tell you instinctively whether you have a colour mix correct or not.

This is not to say that the left side of the brain does not also play a crucial role in the painting process. It is from this side that we perceive visual distinctions in terms of edges and colours. But what really is not required, and can hinder our painting, is the sort of thinking that comes from the language centres of the left side of our brain. This is the 'brain chatter' we all experience, where we mentally speak to ourselves almost constantly.

So to make the shift to the artistic way of seeing, and allow our right hemisphere a little more space, the following tips will help:

Gaining confidence

When someone lacks confidence, they tend to be plagued by the same sorts of undermining thoughts while they paint: 'This looks a mess', 'I'm going to ruin it', 'I can not do this'. These sorts of thought are all coming from the language-oriented, left-brain and are really unhelpful for making the right-brain shift. Be aware that these thoughts are common but serve no purpose in your learning – just try to ignore them! They will naturally subside as you build your confidence. It is only through practice that you will come to relax in the knowledge that you can do it, and in a virtuous circle, your being relaxed will help you to access the right-brain mode for painting.

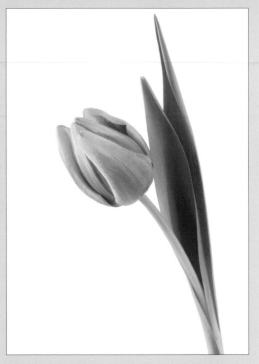

Even though the hue is completely wrong, this tulip is still easily recognisable as a tulip because the tonal values are correct.

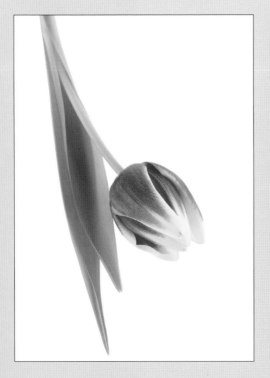

Working upside-down

One thing that separates us from animals is our ability to create a mental construct of the world around using language. The habit we get into is then for us to relate to those labels rather than relate directly to the subject in front of us. For instance, if I say to you 'rose', you will immediately have a mental picture of what that word represents. But if you can cast aside that mental image and remember that every single rose is different in shape, hue and tone, that is the start of being able to really see what is in front of you.

To help break this mental habit, try turning the photograph and painting you are working on upside-down so as to give a 'fresh perspective'. This is a well-known technique which has the effect of quieting the language centres of the left brain – they no longer leap to label the subject because it is now less recognisable to our brains. This allows you to see the shapes of hues and tones as they really are.

Turn your work upside-down regularly as you work, and especially when you are at a point where you feel you are struggling to see what your painting requires next.

Cannonball Tree

A most unusual tropical flower with
orchid-like petals and a very unusual
– but still attractive – centre. Subjects
we are not already familiar with help
us to paint what we actually see, as
we have fewer expectations of what
we think we 'should' see.

Literally stepping back

If I want to identify what my painting needs next by comparing it with
the photograph from which I am working, I will often 'blur' my eyes
so as to make the painting and photograph out of focus, by shifting
my focus to some point in the distance. Another way to do this is to
remove your glasses if you wear them, or even to stand really far away
from the painting.

These techniques have the effect of softening the edges within
your painting or the photograph you are working from and it is then
somehow easier to assess the hue and tone within the piece. I believe
this might also be a way of allowing the right brain to see the shapes
and the requirements of the whole picture. As part of this approach,
regular breaks are important because they allow you the opportunity
to step back and see the painting afresh.

Tip

I like to listen to audio books when I paint as
I find my visual senses are freed when the
language part of my brain is distracted by
listening to someone else talking.

Note

*It is when you come to paint from this shifted, right-brain state that painting
becomes an enjoyable flow – stimulating and relaxing at the same time.*

31

working with watercolour

As well as being practical, watercolour is hugely versatile. Where other media can only vary tone and hue through mixing different paints together, watercolour also makes use of the white of the paper to vary hue and tone. This gives the watercolour artist the ability to recreate a vast array of hue and tone with enormous subtlety.

In this section I show you how I recreate variation in tone and hue through changing the consistency of the paint, layering the paint and the combining and mixing of hues. I will stress here how important it is to recreate the full range of tones in your subject if you are looking to get realistic three-dimensional effects!

The watercolour technique

All watercolours are, by nature, translucent. We use the white paper visible through the translucent paint to create our lightest colours. The translucency of the paint makes it very difficult to paint a light tone on top of a dark tone with any success. Also, the paint often stains the paper, so that it is not possible to completely lift it off if you accidentally paint in the wrong place. It is the fact that 'mistakes' within the lightest areas of the composition can be tricky to rectify that gives watercolours a reputation for being difficult to use.

To allow for this, my technique is all about preserving the lightest areas of the composition and then working on the darkest areas, then the midtones, and repeating this with further layers until the darkest areas of the composition are as dark as they need to be.

To this end the technique relies on creating numerous layers of watery paint. I make sure each layer is dry before I apply the next. This allows the colour and brushwork from the lower layers to be seen through the new layer. The colours visually mix by layering up, but do not physically mix and become muddy.

The best paints for this technique are those that are as transparent as possible. This is especially true when working on the lightest areas of a composition where it is so important to retain the bright white of the paper through any watery layer of paint applied.

The technique may seem time consuming but, as realistic painting goes, it is actually quite quick. A large piece can take me up to two weeks to complete, whereas the projects in this book take between a day and four days.

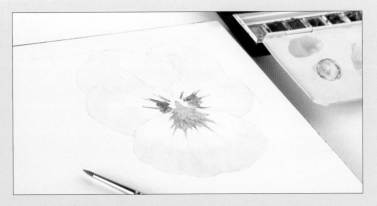

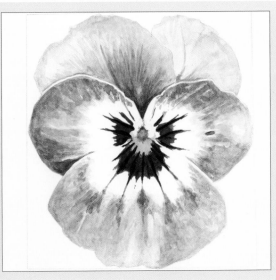

The painting takes shape by gradually building up layers of paint. By working on the dark tones early on (see above), you can easily assess the tonal balance and see how dark the midtones need to be taken for the finished piece (see right).

Properties of watercolours

Transparency

All watercolours are translucent in that you water them all down to create mixes that allow the reflective white of the paper to shine through. However, the pigments do vary in how transparent they are. As you practise painting in this style, these subtle differences in hue and tone become more noticeable.

When I started painting in this way, I naturally discarded all of the colours from my original set that were not as transparent as the others. It was only afterwards that I discovered that watercolours are actually graded according to their transparency or opacity and that I had indeed discarded most of the opaque colours. Opaque colours include cadmium red, cadmium yellow and cadmium orange as well as Indian red and most black paints.

Despite looking almost identical to more opaque paints when dry in the pan, the more transparent the paints, the clearer they appear when used at a very watery consistency as you see much more of the paper reflecting through.

Transparency
Can you see the difference in opacity between scarlet lake (left) and cadmium red (right) painted on this dark background?

On the left is cobalt turquoise light (non-staining), while on the right is permanent alizarin crimson (staining). Parts of each swatch have been lifted out using damp kitchen paper.

Staining

Some hues contain pigments made from very small particles. The smaller the particles, the more likely it is that the hue will stain the paper.

Hues are classed as staining or not, but I have never paid much attention to that rating. The technique I use makes it much less likely that you will need to lift paint off, so the staining properties should not really matter.

If you really have made a mistake, it is more likely that you will be able to lift the colour off the paper using damp kitchen paper if the paint is non-staining.

Permanence

There have been amazing developments in the creation of new pigments in the last fifty years and the result has been colours which are much more brilliant and transparent – which is excellent news for painters of flowers! Those developments have also led to the pigments being increasingly permanent or lightfast, which means they fade less in sunlight than older colours.

Even the most fugitive (non-lightfast) modern colour is still more lightfast than many of the pigments being used in the nineteenth century, so even new paints like opera rose, which does not have the highest lightfast rating, will last a long time. Even so, if you do want to display your paintings, using ultraviolet protective glass in the frame will give you added peace of mind.

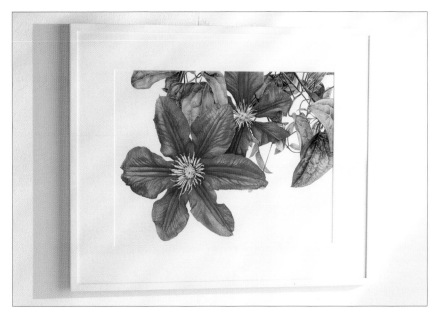

If you use modern watercolour paints and ultraviolet protective glass in the frame, you can hang a painting even in direct sunlight and feel confident it will not fade for a very long time.

Painting tone

Fundamental to my style of painting is getting the balance of tone across the piece correct; more so than getting the hues in your painting accurate. Tone really does make the difference between a flat, unrealistic looking piece and a flower that leaps off the page in vibrant three-dimensionality.

A wide tonal range from lightest lights to darkest darks (also referred to as a high level of contrast) creates visual interest and excitement in a painting. This wide tonal range gives a strong sense of the way in which light has fallen on the subject and so makes the subject appear much more three-dimensional.

Watercolour is superb for accurately recreating the tones at the lighter end of the tonal range. Using the reflective quality of the white paper instead of white paint gives more brilliant, translucent colours – similar to those we see in flowers and leaves. Similarly, at the darker end of the tonal range we can build the paint up thickly, and work with very dark hues to give the darkest of results. This can be used to great effect although it is not what people normally think of when considering watercolour.

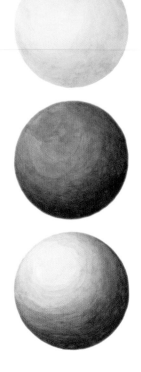

A sphere painted in light tones (top), and a sphere painted in dark tones (middle) both appear flat when compared with a sphere painted with a full tonal range from light to dark (bottom).

> ## Note
> When painting, assessing the whole piece in terms of tonal balance, or contrast levels, is the most important thing to learn to do, and this will be a focus through all the projects.

Creating tone

With watercolour we can alter the tone of the paints we use through three methods: layering, changing the consistency of the paint and combining hues.

Layering

You can use layers to create really subtle changes in tone gradually. Working in layers means that you do not need to get the consistency of your paint correct first time, as long as you always work with a more watery mix than you will ultimately need.

Because capturing the correct tonal range is so important, I would always prefer to do two or three layers of a thinner wash rather than one thicker layer that runs the risk of being too dark.

Building up layers of the same hue will produce gradually darkening tones, as shown on page 42. We can do this with watery or even buttery consistency paint. Take a look at your colours dry in the pans. The darker they appear when totally dry, the darker you will be able to take the tone when working with layers.

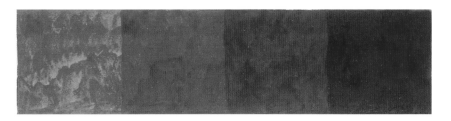

Permanent alizarin crimson is really dark in the pan and several buttery layers of it will create a really deep result. Working with the paint at a buttery thickness does not produce a relatively smooth, even coverage of paint until there are about four layers, as shown on the far right.

Consistency of paint

Altering the consistency of the paint will alter the tone by making a lighter or darker version of the hue we are using. The darker the tone of a hue when in the pan or tube, the larger the tonal range available when using it.

To accurately replicate the full tonal range of a subject we need to ensure we have some really dark hues in our palette.

I identify six key stages of consistency – watery through to buttery– for the hues I use, which have marked differences in tone. These are shown in more detail on page 36.

The tonal range of a light hue, such as cobalt violet (left) is much smaller than the range of a dark hue, such as Payne's gray (right).

Combining hues

If you need to create a lighter version of a particular hue, you can simply keep adding water until you get to a consistency of paint that matches the tone you are after. The only time you would add a lighter hue to lighten tone is when you also want to alter the hue itself. Adding lemon yellow will lighten olive green, but it will also give a more yellow hue.

If you are darkening a hue, you are limited by the tonal range of that hue. If I wanted to take olive green darker than it appears when at a buttery consistency, I would need to darken it by adding a hue of a darker tone; Payne's gray at a creamy consistency, for example. Payne's gray will make the hue more blue. However, If I needed to keep the hue more in line with olive green I might also add a little burnt sienna to compensate for the blue and take the hue darker in tone in a more neutral way. There is more information on mixing neutral hues on page 47.

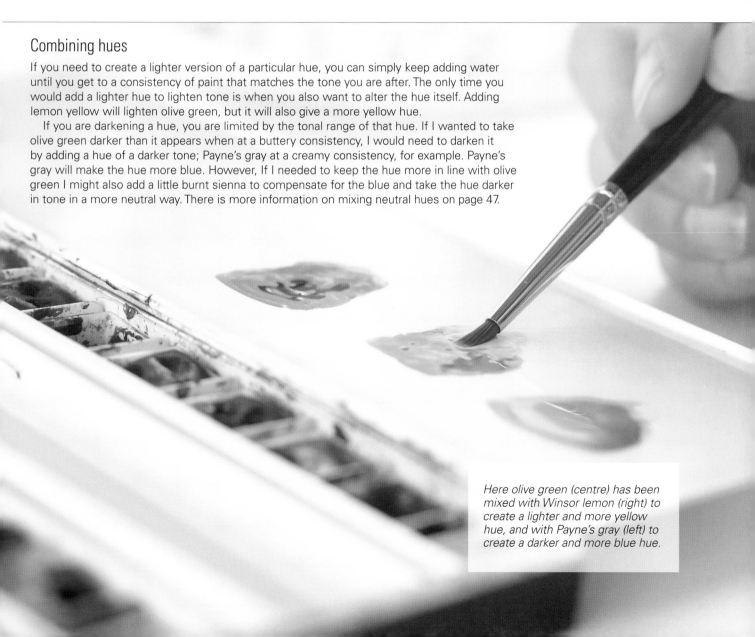

Here olive green (centre) has been mixed with Winsor lemon (right) to create a lighter and more yellow hue, and with Payne's gray (left) to create a darker and more blue hue.

Paint consistency

Watercolours can be used with more or less water, and the amount added to the paint will create different tones, as explained on pages 34–35. The following six main consistencies – described by comparison to water, milk, cream and butter – are used throughout the book. Experiment with creating these consistencies with your own paints to familiarise yourself with each one.

water

Between water and milk

Milk

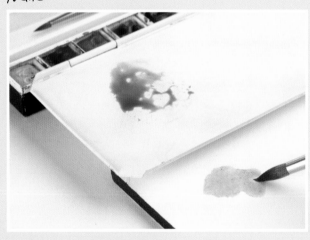

Between milk and cream

Cream

Butter

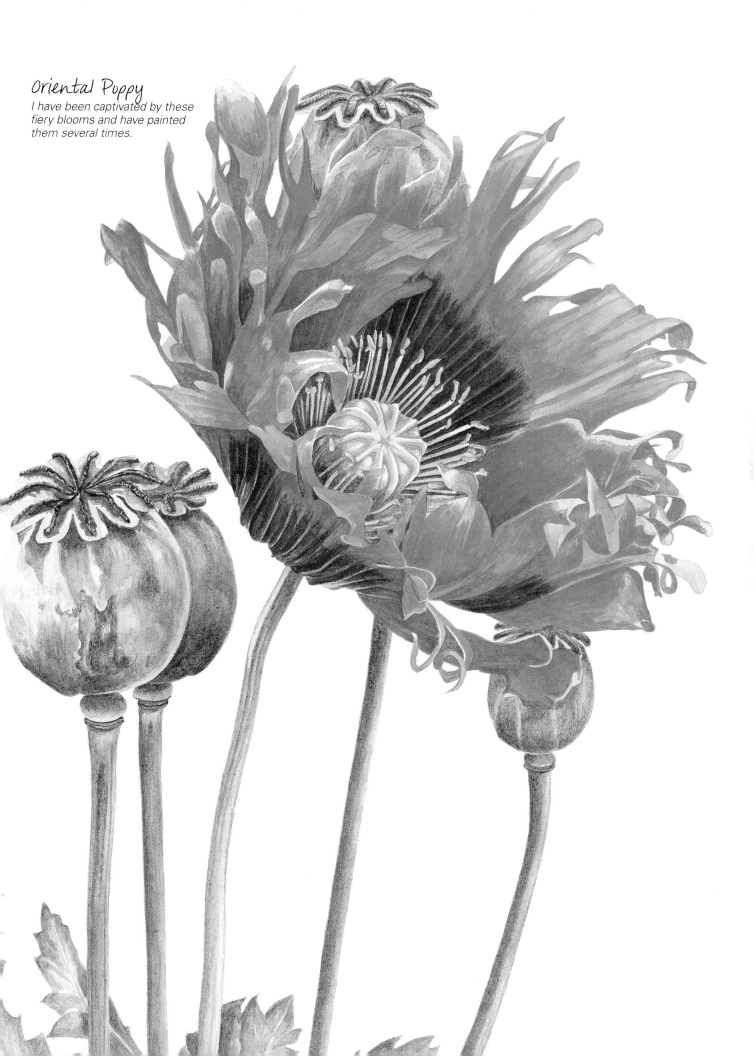

Oriental Poppy
I have been captivated by these fiery blooms and have painted them several times.

Painting hue

Flowers are so often appealing because they are bright. This quality is to do with reflecting a lot of light – so that flowers often seem to glow. In order to best replicate these bright hues I choose paints with brilliance (intensity) coupled with transparency so the brightness of the white paper shows through in the lighter tonal areas of the flower.

To paint successfully we need to use pigments that can best match the wide array of colours we see in flowers, and we need to learn to mix them to a high degree of accuracy so that we can achieve the very subtle differences in hue that we see. The technique I use makes this much less difficult than it first seems.

My palette

At the time of writing I use twenty-two hues, mostly from Winsor & Newton. My palette is always a work in progress and I add to it as new hues are produced, or when I come across new hues from different brands. I find that I cannot achieve each of these hues in as brilliant a way through mixing different hues.

My palette reflects the hues I need to re-create when painting flowers. I have more red and purple hues than blue hues, which reflects the fact that there are fewer truly blue flowers in nature. I also have many greens which are so useful for foliage.

Below and on the opposite page are samples of these twenty-two hues which include the qualities you should look for if using a substitute. It is by no means required that you use these very hues, but the transparency and brilliance of the hue you use is important to getting the right results with this technique.

The hues are shown through the six different consistencies described on page 36, which helps to give an idea of the range of different tones that can be achieved with each paint.

At first glance you might think of an area of a flower as being one colour, but you will usually find a great deal of variation in hue when you look more closely.

Note

Many of the paints in my palette are permanent. This is important: non-permanent versions are available (particularly in Students' ranges) but these include less pigment and more filler, which makes them less intense and transparent.

winsor lemon

This yellow is a good mid-yellow in that it is neither biased towards red or green. It is transparent and brilliant. Steer clear of opaque yellows such as cadmium yellow or lemon yellow (nickel titanate).

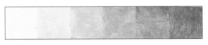

Olive green

A must-have earthy (brown) green which is very useful for leaves and stems.

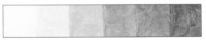

Permanent sap green

A brilliant natural green. Hooker's green is a similar hue.

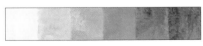

winsor green (yellow shade)

A very vivid, artificial-looking green that is sometimes useful for the leaves of tropical flowers. A very small amount can lift a green and make it more brilliant. Viridian is a good similar green.

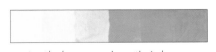

Cobalt turquoise light

A very brilliant light green-blue, which is unmixable using the other colours in this palette.

winsor blue (green shade)

A dark, cool blue. A useful addition to greens sometimes. Phthalo turquoise is a good alternative.

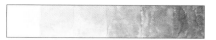

Cobalt blue

A light blue with hints of red.

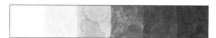

French ultramarine

A really transparent dark blue with hints of red.

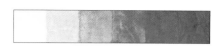

Bright violet

The brightest and darkest mid-purple I have found. This is produced by Holbein.

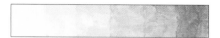

Cobalt violet

A must-have light pinkish-purple which you can not get near through mixing. It is really brilliant, which makes it so useful for purple flowers.

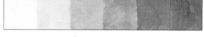

Quinacridone magenta

A brilliant pinkish purple.

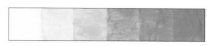

Opera rose

By far the most brilliant hue produced, it is superb for the brightest pink flowers and a thin wash can really lift the brightness of purple and red flowers.

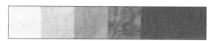

Permanent rose

A brilliant, dark, pink-red with just a hint of yellow making it a more natural pink than opera rose.

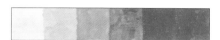

Permanent alizarin crimson

A dark red that is a little duller (more brown) and darker than permanent carmine when it dries, which makes it very useful for deepening other reds such as scarlet lake.

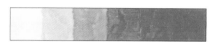

Permanent carmine

An intense, dark and brilliant red with a hint of blue. This is good for using with scarlet lake to create a brilliant mid-red.

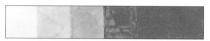

Quinacridone red

A red that is light in tone but extremely brilliant; this is useful for the brightest red flowers.

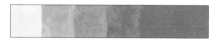

Scarlet lake

A brilliant, transparent red with a hint of yellow. Even at a buttery consistency it is not very dark in tone so I often combine it with permanent carmine or permanent alizarin crimson when I need a darker mid-red.

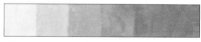

Translucent orange

A brilliant, transparent mid-orange (equal parts yellow and red), manufactured by Schminke. Mixing a red and a yellow to create orange tends to result in a more opaque hue, so a ready mixed transparent orange is very useful.

Yellow ochre

A light semi-transparent earthy yellow-neutral hue.

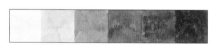

Payne's gray

A very transparent, very dark, blue-grey. The pigment is very dark and intense so a tiny bit goes a long way. The Winsor & Newton one is very blue which I like. I use this hue a lot for darkening other hues.

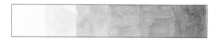

Burnt sienna

A very transparent, dark, warm orange-brown neutral hue. The basis of all my brown and black mixing.

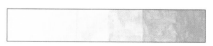

Davy's gray

A semi-transparent light mid-grey, this is very useful when working on shadows in very small areas (such as stamens) and when working on white flowers.

white gouache

Gouache is a more opaque version of watercolour, so it works well for light details such as hairs which are themselves opaque and need to be added at the end of a painting. In the example here, white gouache hairs have been added over a very dark background.

Laying out your palette

I lay my palette out roughly in accordance with the Munsell colour wheel (see below right), with orange through to purple on one side and green through to blue and the neutral hues on the other side. White gouache fits in where there is space. This is illustrated below.

Getting to know your hues

Paints in the pan often look quite different (and obviously a lot darker) than they do when mixed with water and applied to the paper. It is therefore really important that you spend some time getting to know your hues. I suggest you create little swatches like those on pages 38–39 and experiment with the hues in different consistencies. Treat this as fun – as play. Use a sketchbook and get messy! It will not be wasted time.

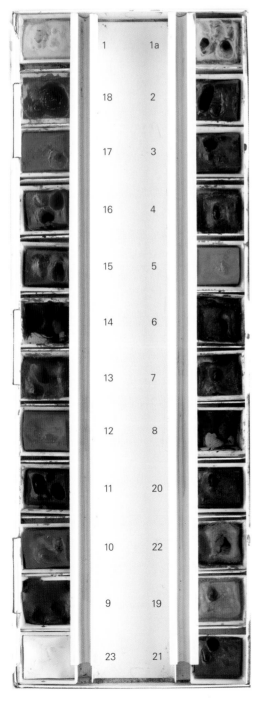

Colours

1 and 1a Winsor lemon
2 Olive green
3 Permanent sap green
4 Winsor green (yellow shade)
5 Cobalt turquoise light
6 Winsor blue (green shade)
7 Cobalt blue
8 French ultramarine
9 Bright violet
10 Cobalt violet
11 Quinacridone magenta
12 Opera rose
13 Permanent rose
14 Permanent alizarin crimson
15 Permanent carmine
16 Quinacridone red
17 Scarlet lake
18 Translucent orange

Neutrals

19 Yellow ochre
20 Payne's gray
21 Burnt sienna
22 Davy's gray

Gouache

23 White gouache

Tip

I use two yellow pans because, being so pale, yellow can easily get dirtied when mixing. This way one pan can be reserved for mixing greens, and the other for oranges, which saves on cleaning!

This shows how my pans map on to the Munsell colour wheel (see opposite), but it also shows how hard it is to judge their true hue in the pan, owing to the tonal differences. For example, from the picture below, it is very hard to judge that opera rose (12) is actually more purple than permanent rose (13).

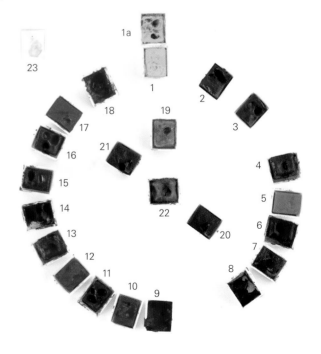

The colour wheel

Fundamental to understanding how to mix hues is to have an understanding of the relationships between them. To illustrate this I like to use the colour wheel devised by Alfred Munsell in 1905. Different from the standard colour wheel, which has red, yellow and blue as the three primary hues, Munsell's wheel was devised to show hue progression through consistent steps of hue change in equal gradations.

Munsell selected five primary colours: red, yellow, green, blue and purple; and five secondary colours: yellow-red, green-yellow, blue-green, purple-blue and red-purple. I think this system best reflects how we perceive relationships between hues because there is less space between red and yellow when compared to the standard colour wheel.

The image below shows the paints of my palette arranged in the Munsell colour wheel, which shows more clearly why I have arranged them as I have. Each of my main hues is shown in six different tones (produced with the consistencies explained on page 36).

I have also included neutral hues in the centre. Davy's gray (22) is a true neutral, so it sits right at the centre. Payne's gray (20) is a blue neutral, burnt sienna (21) a red neutral and yellow ochre (19) a yellow neutral, so each sits nearer their respective part of the outer colour wheel.

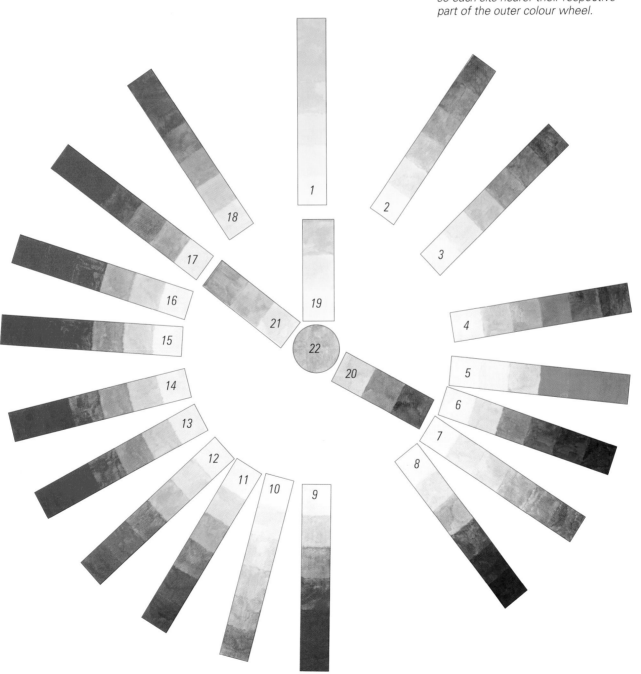

Mixing hues on the paper with layers

By building up hue gradually with relatively watery layers of paint, you can adjust it with every layer of paint you apply. Take a look at the most watery versions of the hues in my palette. All of the reds, for instance, look quite similar in this most watery state (see below).

 When you are working with watery layers, it is not vital to mix the hue correctly the first time around. So long as you are working with fairly watery consistencies, the opportunity to adjust your hue as you build up will remain. Although we are trying to closely match the hue we are observing, remember that you have the power to adjust the hue through layers. This will take off any pressure you feel in terms of getting it exactly right each time.

Colour corrective washes

In addition, using layers to mix colours is not just about making 'mistakes' with our colour assessments. As you gradually build up the tonal values and depth of hues in a painting, the hue may appear slightly different. Hue is relational too. You may not realise that your orange flower is slightly too yellow until you complete the bright green leaf next to it. That is when a watery wash of an orange over the top of dry paint will serve to subtly correct the hue. We will cover colour corrective washes throughout the projects.

On the palette (foreground) are watery opera rose and quinacridone magenta. Here they look very similar, but as they are built up in layers on the paper, their hue and tone will strengthen and darken until they are quite distinct.

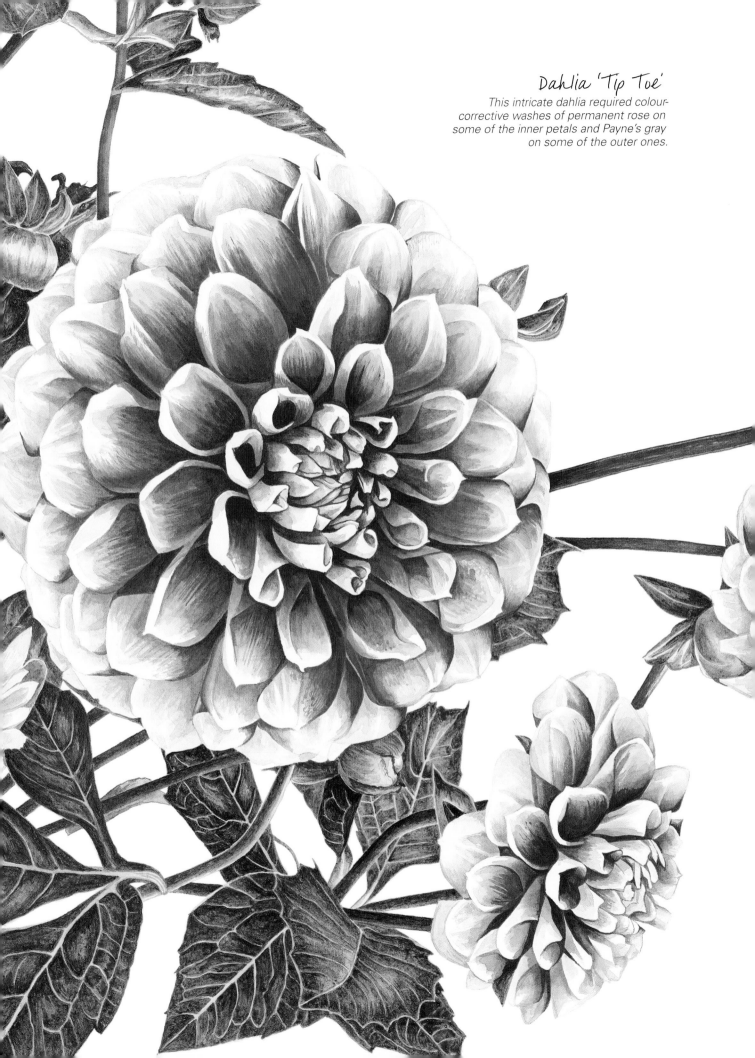

Dahlia 'Tip Toe'
This intricate dahlia required colour-corrective washes of permanent rose on some of the inner petals and Payne's gray on some of the outer ones.

Mixing hues in the palette

Although working with watery layers builds in an ability to adjust hues, we do of course want to try and ensure that we are as accurate as possible with our hue as we apply it. Ideally I aim to use a combination of just two or three hues in a mix as this is both easier to mix and tends to give the most transparent results. Having as many hues as I do in my palette, I usually find that this is possible.

In this example we are going to paint viola petals (the project on pages 78–85). Below are the steps I use for getting the closest mix possible.

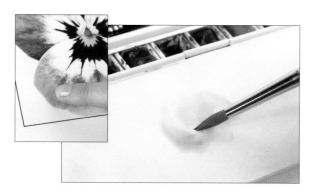

1 Have your reference (the photograph, finished project image or real life flower) close to your page to make visual comparison as easy as possible. Identify a particular shape with a single hue (see inset). Decide which hue in your palette is the closest match to the hue area. This is your base hue. In my palette it is French ultramarine (my most purple blue). Take a bit into your pan and dilute it to the consistency between water and milk.

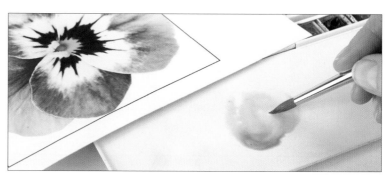

2 Referring to the colour wheel (see pages 40–41), ask yourself in which direction (if any) the hue needs to move and whether it needs dulling down to make it more muted and less vibrant. In this case the hue needs moving towards red but does not need dulling down. Add in a very small amount of the relevant paint to get the right hue. A good place to start is the hue immediately next to your base hue in the direction you need the hue to move. In this case, the colour needs to become more red-purple, so we add bright violet.

Note

You are assessing hue rather than tone. Remember that you will usually be working with a slightly lighter tone in the palette (i.e. with the paint at a more watery consistency) than the eventual colour on the paper needs to be, so that we can match the lightest tones within the hue area.

Note

In some instances, the hue that may be most suitable to mix in may be one of the neutral hues. This will always be the case when the hue needs to be muted or dulled down. We will cover the specific cases during the projects. Steer clear of using white gouache in your mixes. If you simply need to lighten a hue, dilute it.

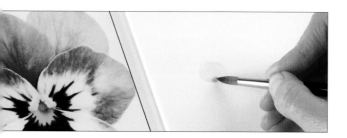

3 Test your colours out on some spare watercolour paper or in your sketchbook before you apply them to your painting. Using the same brush to paint with as you do to mix can slightly shorten the life of your brushes, but it ensures more of a flow to the process as you do not have to keep swapping between brushes as you work.

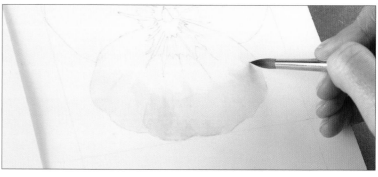

4 Once you are happy with the mix you have made, use the same brush to apply the paint and let it dry. You can always come back and adjust the colour with a subsequent layer. This process gets a lot quicker and easier once you have become familiar with your hues.

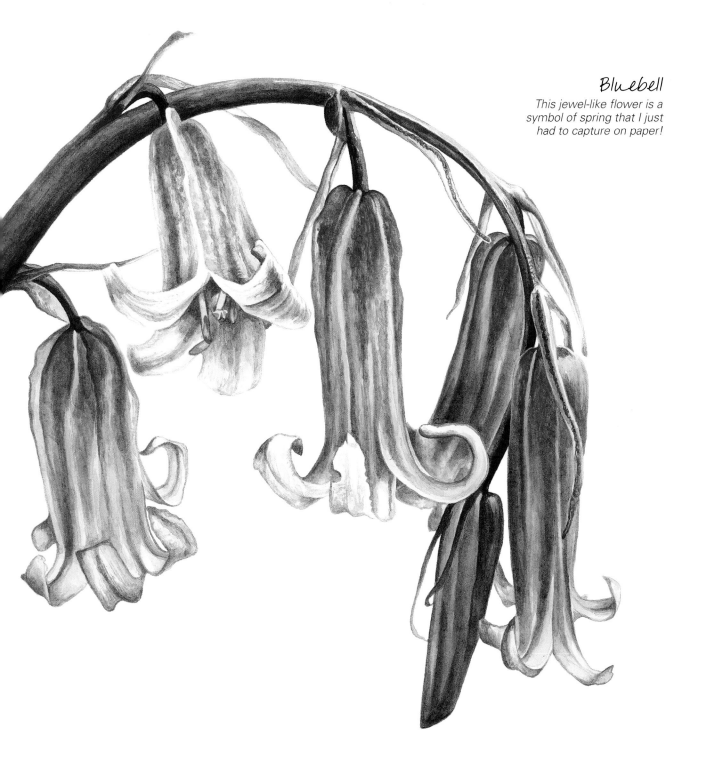

Bluebell
*This jewel-like flower is a
symbol of spring that I just
had to capture on paper!*

Note

*I only ever create small amounts of my mixes at any one time. It means I have to
re-mix often, which in turn means I end up with variations in the mix I am working with.
However, those variations are usually helpful because, as we saw on page 41, most
flowers have a great deal of hue variation within them when you look in detail. Having
to re-mix also means that you can keep adjusting your hues as your painting develops.
Remember, seeing hue is relative. Therefore, making changes to the hues on which we
are working will be inevitable as our painting develops and we can better assess the
hues and tones within it.*

Mixing greens

Foliage is crucial for flower paintings and greens are crucial for foliage. They can often be tricky to get just right. This is the area of the palette where I often end up mixing more than two hues at once.

I have two core greens that I use time and time again, either individually or as a mix. These are olive green – an earthy, yellow-brown green; and permanent sap green – a fresher, more blue organic green, as its name suggests. However, the range of greens in foliage is huge and so I do use a wide range of hue mixes. I have included some common mixes in the table below.

I suggest you try making your own version of this table as a way of familiarising yourself with your hues. You can also try doing something similar for different hue ranges – for instance reds and purples. It is a very useful exercise for getting to know your hues.

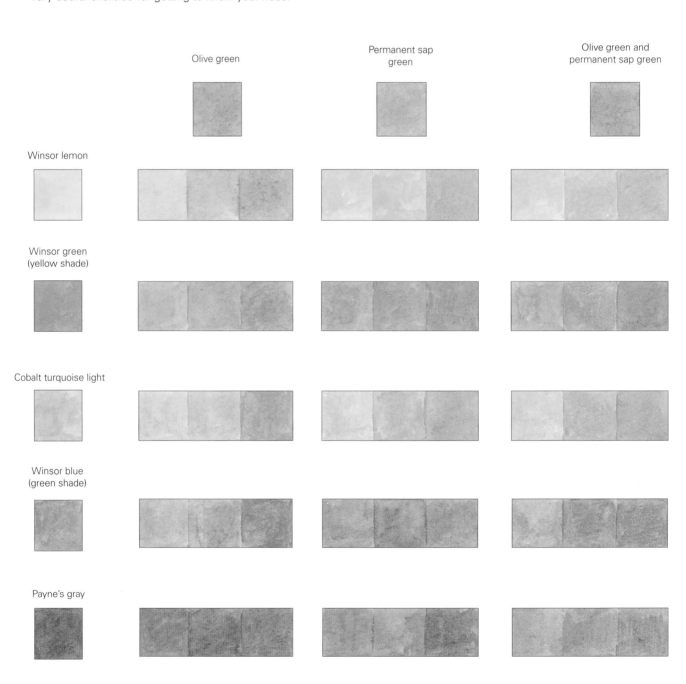

	Olive green	Permanent sap green	Olive green and permanent sap green
Winsor lemon			
Winsor green (yellow shade)			
Cobalt turquoise light			
Winsor blue (green shade)			
Payne's gray			

Mixing neutrals

Mixing blacks, browns and greys

I prefer to mix my own blacks and dark browns because the ready-mixed paints available are opaque and so do not lend themselves to being used in layers. I like to use a mix of burnt sienna and Payne's gray. The orange of the burnt sienna combines with the blue of the Payne's gray to produce a neutral hue.

The same paints can be used to produce a range of transparent grey hues when used in a watery consistency. The most neutral of these mixes is a very close match to Davy's gray. Davy's gray is more opaque than using the mix of burnt sienna and Payne's gray, but I include it in my palette because there are occasions (especially when working on stamens) where I want a light neutral grey but do not want the paint to be too watery, as would be the case if it was mixed using the very dark Payne's gray and burnt sienna combination.

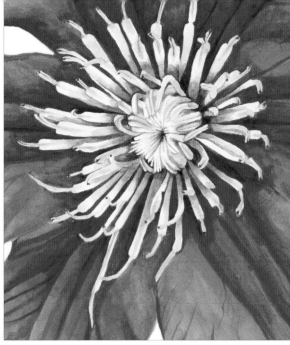

This shows a variety of neutral hues, from pure burnt sienna on the left to pure Payne's gray on the right, with combinations in differing proportions in between. The top row shows the paints in a creamy consistency, while the bottom row shows watery washes.

If I were to use a really watery mix of Payne's gray and burnt sienna when applying a colour corrective wash (see page 42) to these stamens, there would be the risk that the dark pink paint might bleed into the stamens, ruining the crisp edges I had created. For this, it was safer to use Davy's gray in a thicker consistency to pick out the parts of the stamens that need to be darker.

Mixing with yellow ochre

Using burnt sienna as the base for a beige will give a red-tinged beige. On occasion you might want a less red beige. In these cases, try mixing yellow ochre and burnt sienna for another great neutral mix.

Don't get hung up on hue!

While I always try to get the hue as accurate as possible when painting, I think it is worth remembering that the way we see a hue does differ depending on the light we are in. There can be quite a bit of difference between the hue you apply to the paper and the hue of the subject without it looking wrong to the viewer.

Similarly, there is huge variety in nature. Even within a particular flower there is a wide range of hues between individual blooms. Flowers also change colour with age. All of these things mean that it is not vital to your piece for the hue to be one hundred per cent accurate – it will still look realistic.

> *Tip*
> An extreme example of the principle that your hues need not be completely accurate to life to be realistic can be seen in the blue tulip on page 30. It may not look realistic, but we can still identify it as a tulip.

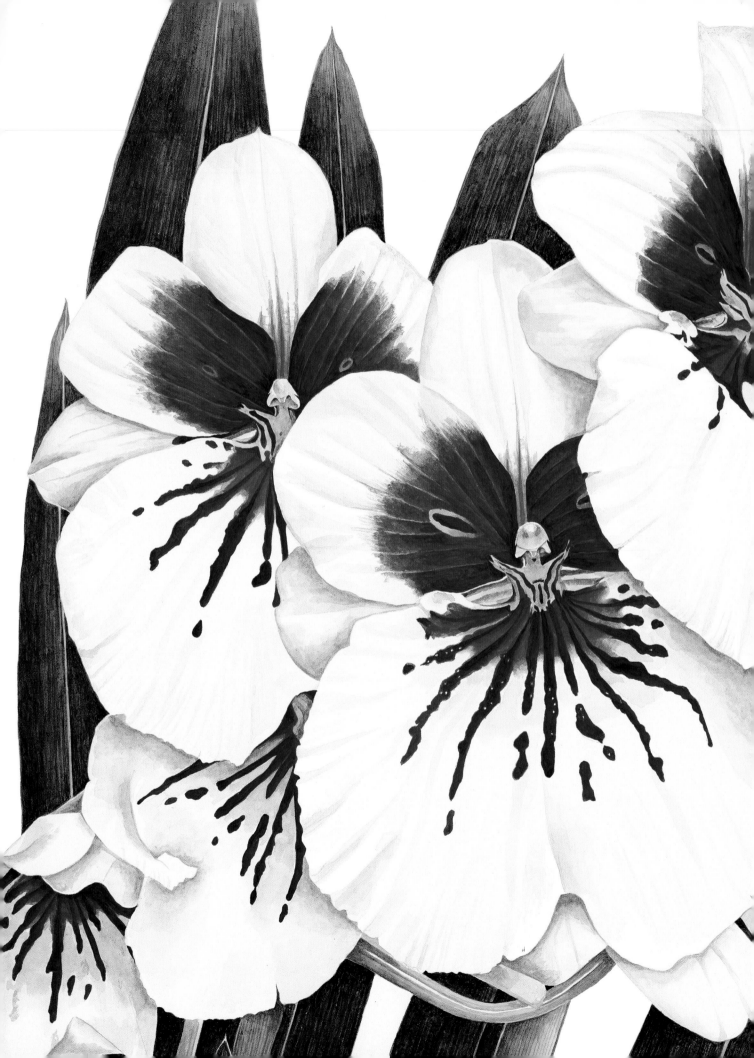

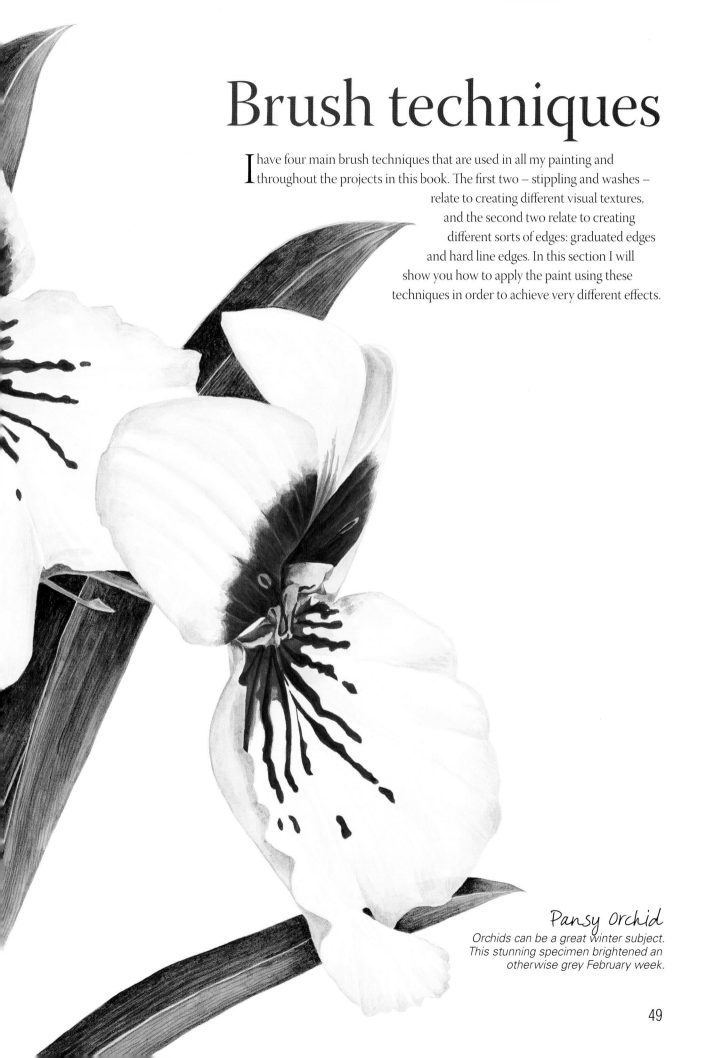

Brush techniques

I have four main brush techniques that are used in all my painting and throughout the projects in this book. The first two – stippling and washes – relate to creating different visual textures, and the second two relate to creating different sorts of edges: graduated edges and hard line edges. In this section I will show you how to apply the paint using these techniques in order to achieve very different effects.

Pansy Orchid
Orchids can be a great winter subject. This stunning specimen brightened an otherwise grey February week.

Holding your brush

For optimum control I always hold my brush as if I were holding a pen, about 1–2cm (½–¾in) up from the bristles. The angle at which I hold the brush varies depending on the method I am using to apply the paint.

I always rest my hand on the paper. It would be impossible to get the necessary steadiness and control without having your hand rest on something. So long as your hand is clean and dry you need not worry about having it mark the paper, although you obviously must make sure that the paint is fully dry wherever you rest your hand.

I have seen people use a piece of kitchen paper between their hand and the paper but if you do this you will not feel whether the paint is still wet, which could result in accidental lifting or smudging of the paint.

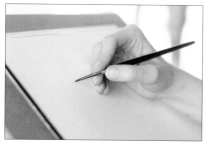

Held at a low angle

For three of the four techniques (all except hard line edges), I hold my brush at a low angle because it keeps the brush nearly parallel to the page. This allows me to use the sides of the brush's bristles.

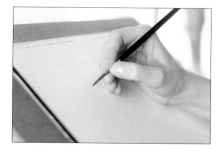

Held at a high angle

When creating hard line edges I use just the tip of the brush, holding the brush at a higher angle so that it is nearly perpendicular to the page.

Applying the paint

When you really look at a subject, you see that as well as breaking it down into shapes of different colours (as we have looked at on pages 28–30), you can also break it down into shapes of what I call 'visual texture'.

These shapes could be the result of shadow, highlight, patterns of colour on the subject, the subject's physical structure, as well as the actual physical texture of its surface. In the case of this viola the petals would be velvety and smooth to the touch, but have a colour pattern to them which creates areas of visual texture.

Whatever their cause, when we are translating into two dimensions we simply need to recreate the shapes of visual texture, whether the surface itself is rough or smooth, as accurately as possible.

In the picture of the viola to the right, I have identified the shapes of two different visual textures, and two different types of edges. These different visual textures and edges correspond to the four main brush techniques I use, which are explained on the following pages.

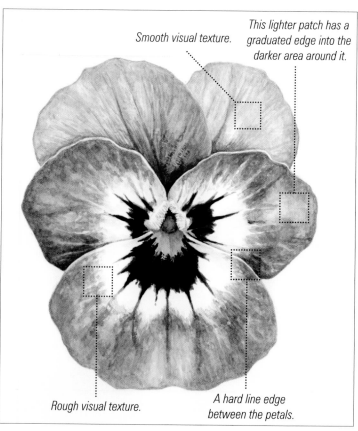

Smooth visual texture.

This lighter patch has a graduated edge into the darker area around it.

Rough visual texture.

A hard line edge between the petals.

Rough visual texture – stippling

Hugely common in flowers and the natural world, shapes of rough visual texture contain lots of smaller marks to create a non-uniform, mottled look. These marks can be the result of light hitting a physically textured surface (which would be rough if you were to touch it), or, as with the marks on this viola, they can be the result of colour patterns on an otherwise physically smooth surface.

Stippling

Stippling is what I call the technique I use to recreate this rough visual texture. The size of the stroke varies but the technique is dependent on the length of the bristles themselves. For this technique the tear-drop shaped spotter brushes I use are important because they hold the required amount of paint. The brush size used and the consistency of the paint make a huge difference to the appearance of the texture created.

As always in my work, the technique is about recreating the shapes I am observing, so it will vary a little according to the appearance of the texture I am looking to recreate.

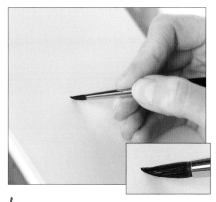

I Load the brush with milky paint. Hold it at a low angle, with the brush handle resting on your hand as shown. Put the tip of the brush to the paper first (see inset)

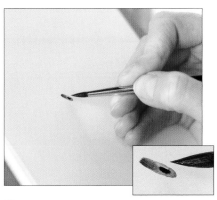

2 Make a small stroking motion towards the handle end of the brush and lift the brush away. This will produce a short brushstroke with a pool of paint at the end (see inset).

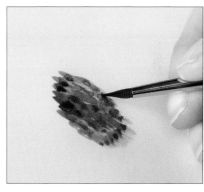

3 Repeat the technique while the paint is still wet to build up a mottled, non-uniform application of paint on the paper. Reload the brush as required.

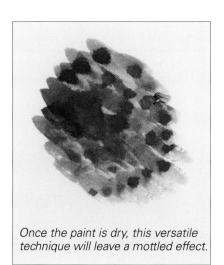

Once the paint is dry, this versatile technique will leave a mottled effect.

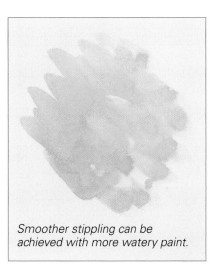

Smoother stippling can be achieved with more watery paint.

Smooth visual texture – washes

Whenever there are smooth, even shapes of colour on the image, our brushwork needs to reflect this. Take a look at the swatches on pages 38–39 and inspect the brushwork. These swatches show just one layer of a hue at the six key consistencies. You will see that the paint gets more patchy, and the brushwork more visible as the paint gets thicker. With watercolour, it is tricky to get a totally even coverage of paint. Because it is transparent, any overlaps of paint create two layers – and therefore a small but noticeably darker patch often referred to as a hard edge, or hard line edge. This is less obvious when working with more watery paint. With more watery paint it is easier to move the paint around on the page as you apply it and therefore avoid as many overlaps.

 This is yet another reason why I prefer to work in lots of watery-milky layers. To build up the required depth of colour that way means it is easier to create smooth, even colour when it is required.

 When aiming for smooth even colour, there are differences in how I apply paint when it is watery and when it is thicker. In all cases I almost always apply the paint in the direction of any markings on the subject. This is so that, if any brush strokes do overlap, any faint overlapping marks will replicate any markings actually visible on the flower.

Compare the edge of the paint to the centre of the shape. Three milky washes of cobalt turquoise light have been overlaid to create a smooth finished appearance in the centre.

These examples show that the faint overlaps created by multiple washes can be useful in helping to suggest the shape and visual texture of the flower.

Washes with watery paint

Applying watery paint is known as a wash or, sometimes, a glaze. When applying a wash on top of dry paint, you need to apply it with a light touch so as to avoid lifting the layers of paint below.

 If you are trying to recreate smooth visual texture with only one layer of paint, you need to be careful to avoid hard line edges created when your brush runs out of paint before the area is filled. Additional layers can help to hide these hard edges somewhat, so this is not critical for areas where you will apply more layers. This exercise will show you how to work with hard line edges.

Note
Do not forget to let each wash of paint dry completely before applying another.

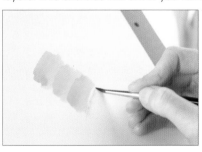
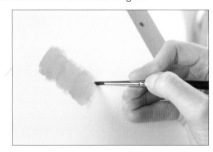
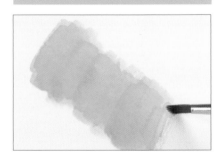

1 Holding the brush at a low angle with the brush handle resting on your hand, work in a sweeping, side-to-side motion with the full length of the bristles in contact with the paper. Applying the paint in one direction only (e.g. from left to right), creates an area with hard line edges as shown.

2 Once dry, these hard line edges can be partially hidden with an overlaying wash made in the same direction. The wateriness of the overlaying wash means it can be moved around on the paper while wet to avoid any pooling of paint, which also helps to keep the area as smooth as possible.

This close-up shows where the second glaze has been overlaid on the first. Notice how the overlaps are much softer than before. Any faint lines that are left can be hidden with further washes, or used to help suggest the shape of the flower you are painting.

Washes with milky paint

Using paint of this consistency will give a thicker wash. This is similar to a standard wash, but the way I apply it reminds me of colouring-in with felt tip pens. The paint is moved back and forth with the brush quite quickly, which avoids the sort of pooling of paint created with the stippling technique (see page 51).

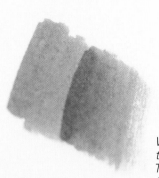
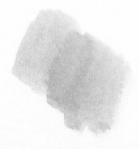

With paint of a milky consistency, the paint will dry more quickly on the paper. Any hard line edges created will be more pronounced (left). To avoid this, you must work more quickly when reloading the brush (right), so that your first patch of paint has not fully dried.

Smooth visual texture with creamy or buttery paint

Sometimes the depth of colour required in an area of your painting would make building up milky layers of paint just too time consuming. In the areas in which I am confident that I need to take the paint very dark I will use the paint thickly. If smooth, even colour is required, I use a combination of the stippling technique and milky wash technique to make the coverage as even as possible.

It is almost impossible to get a completely even coverage in one layer, however, largely because you need to keep adding small amounts of water, thus altering the consistency a little, just to keep the paint wet enough to apply.

For a smooth result I always let the paint dry then apply another layer on top, focussing on patches where the paper was more visible in the first layer – essentially filling the gaps.

Tip

If you inspect any of my paintings close-up, you will see plenty of hard line edges, even in areas of smooth visual texture. The reality is that even smooth-looking flowers have a bit of rough visual texture when you look very closely – so do not worry too much about creating unwanted hard line edges.

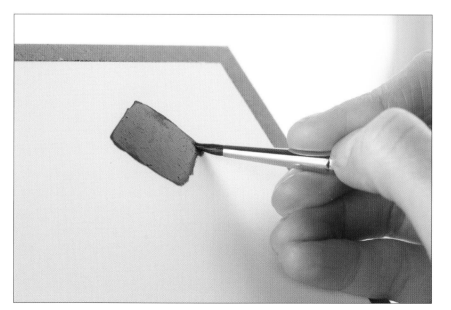

When aiming for smooth visual texture with creamy or buttery consistency paint, some paints may be a little uneven after one layer (above left). To smooth it, allow it to dry and apply a second layer (above right). You can add further layers for an even smoother surface, but be careful not to make the tone too dark.

Hard line edges

When working on shapes of smooth visual texture, we want to avoid creating hard line edges. In other parts of our flower paintings, such as where edges of petals meet the white background of the paper, or where they overlap each other, we want to deliberately create them. Hard line edges are also seen in visible veining, creases or folds.

Depending on the tone required for the line, any consistency of paint can be used from watery through to buttery. To get a really crisp line I hold the brush fairly vertical and use the point of the brush to create a neat line. A steady hand is important and, where possible, I stabilise my hand by resting it on the page.

Creating a hard line edge with a large brush

I usually use a larger size 3 brush to create hard line edges at the edges of petals or leaves when I am working with washes or milky consistency paint.

The pointed tip of the brushes I use means that you can get a really crisp line even with the larger (sizes 3 or 5) brushes. The brushes do not last forever, so check from time to time that yours still has a good point to it.

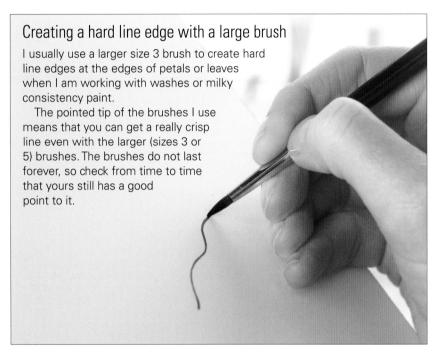

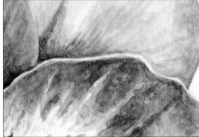

Hard lines at the edges of shapes

Getting hard line edges right is what gives our painting clarity and the sense that it is crisp and in focus. It is important to have crisp hard line edges at the edge of petals and also around stamens. They contribute disproportionately to the success of our paintings and can be neatened near the end of the painting as part of the finishing touches.

Creating a hard line with a small brush

The smaller brushes (1, 0 and 000) are mainly used in the latter stages of painting when I am picking out details. For this kind of precision work the tips of the larger brushes are simply too large to create the small details we need, such as outlining stamens (where the paint might be quite thick in consistency) and creating veins (where the paint might be more watery).

This technique can also be used with white gouache to create small hairs in the stamen areas or on buds.

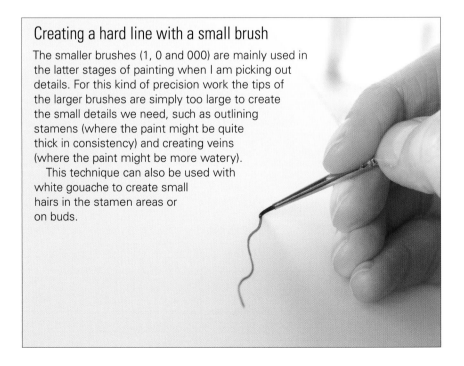

Graduated edges

The shapes of colour in our subjects have different sorts of edges to them. Graduated edges are where the transition from one shape of tone or hue to another is gradual and the tones or hues run smoothly into one another. This could be the result of lighting, or the markings on the actual subject – for our purposes it does not actually matter – we just want to paint what we see.

Where it is obvious that there is a graduated edge, I will try to create it from the outset using wet paint. However, it is perfectly possible to create graduated edges from an unwanted hard line edge even after its has dried, by lightly scrubbing it or by adding a further layer. As always, the key is not to have taken the whole area too dark in tone. This is another reason why working with lots of watery or milky layers is such a forgiving technique.

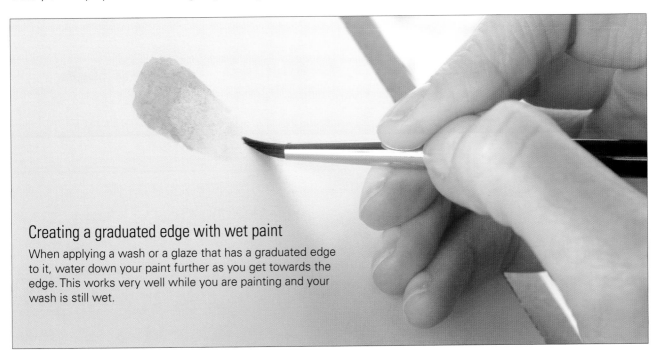

Creating a graduated edge with wet paint

When applying a wash or a glaze that has a graduated edge to it, water down your paint further as you get towards the edge. This works very well while you are painting and your wash is still wet.

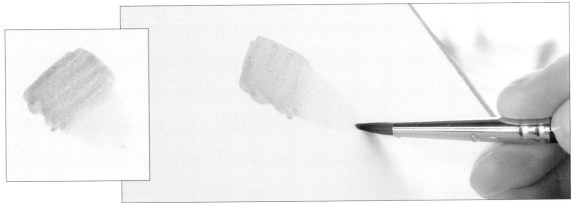

Graduating hard line edges

If your wash has already dried leaving a hard line edge where you do not want it (as in the inset), you will need to use a wet brush to work into that colour – lightly scrubbing the paint to lift and move the dried pigment around so as to soften the edge.

Alternatively, if you find that you can afford to take the tone a little darker in both the dark and light parts, then you can soften the unwanted hard line edge by adding a further layer of paint to the area of transition and lighter part of the graduated edge, in much the same way as on page 52.

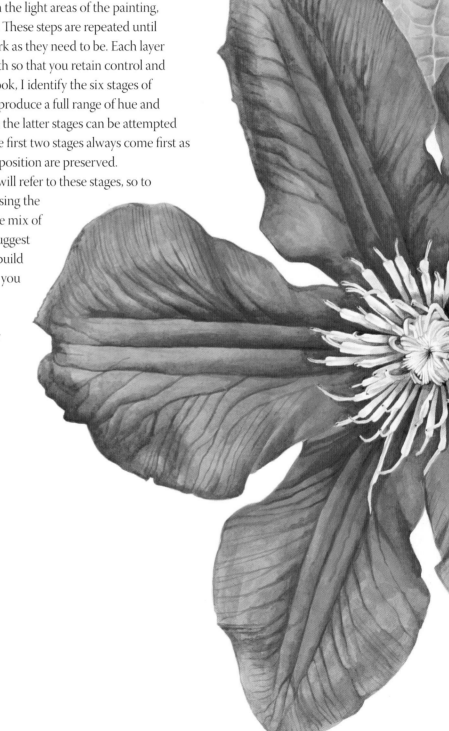

Painting flowers

My technique consists of working on the light areas of the painting, then the darks, then the midtones. These steps are repeated until the darkest parts of the painting are as dark as they need to be. Each layer is applied to dry paper or paint underneath so that you retain control and avoid muddiness. In this section of the book, I identify the six stages of painting that will help you successfully reproduce a full range of hue and tone in your own flower paintings. While the latter stages can be attempted in a different order, it is important that the first two stages always come first as these ensure the lightest areas of the composition are preserved.

Each of the projects later in the book will refer to these stages, so to introduce and explain these stages I am using the example of a pale rose, which uses a subtle mix of hues, and contains a large tonal range. I suggest you try this exercise in order to help you build up your skills and confidence and to help you gain an understanding of these different stages of painting, which will be really helpful when you tackle the projects later in the book; and – of course – your own flower paintings.

Clematis 'Rosemoor'
This gloriously bright flower just shouted at me to be painted.

The six stages of painting

Use the finished painting below as your reference material to reproduce. It can be easier to see the tonal range when hue has been removed altogether which is why I am including a greyscale version of the rose (see opposite).

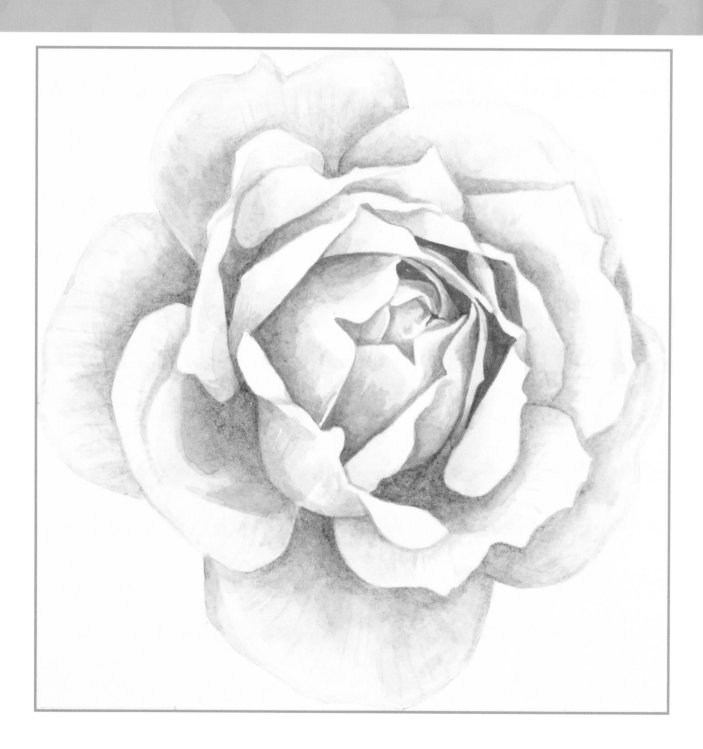

You will need

Watercolour paints: permanent rose, burnt sienna, cobalt violet, scarlet lake, opera rose, yellow ochre, Payne's gray and WInsor lemon

Spotter brushes: sizes 5, 3, 1, 0

Watercolour paper: 300gsm (140lb), white, Hot Pressed finish, 18 x 25.5cm (7 x 10in)

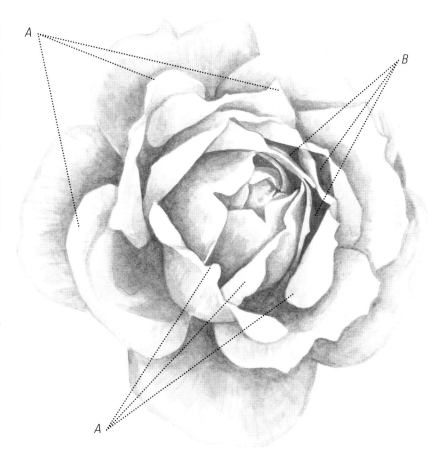

Tonal image
This greyscale version of the rose helps to show the tonal range. The brightest highlights are marked 'A'. The darkest shades are marked 'B'

Stage 1 – Highlights

I always start by working with a watery wash on the lightest areas of the composition. I try to create a mix to match the lightest possible part from within that area.

In this rose the lightest areas are the edges of the inner petals. These are so light in colour that it is almost the same as the paper. I have marked them 'A' on the black and white photograph.

Consistency and hues

The closest hue match to the very lightest hues is permanent rose. Mix an extremely watery wash containing the hue. It should be almost pure water with the most minute amount of paint you can manage – I do not think this stage can be too watery, unless you use no pigment at all!

Note

In this case, the palest colour can be applied all over the rose. This is because all of the rose contains very similar hues and so this palest wash will not create an undesirable visual mix when we apply the subsequent layers of paint on top. We will cover what to do when a composition has several hue elements in the individual projects on pages 72–125.

1 With the picture lightly drawn out as described on pages 24–25, identify the lightest area of the composition. Using watery permanent rose and the size 5 round brush, lay in a wash over the whole image. This should be so watery that it barely tints the paper.

Stage 2 – Isolate the highlights

In order to make sure we do not accidentally take our highlights too dark, we need to make sure that we can easily see them. We do this by applying a second layer of the paint everywhere except the areas of highlight – thereby isolating them. This will help to indicate the direction of growth as the layers and small overlaps of paint build up during the painting, echoing the veins of the petals.

From this stage on, I apply the paint broadly in the direction of growth – outwards from the recessed bases of the petals towards the edges.

Consistency and hues

As in stage 1, use permanent rose and keep the wash very watery.

2 Ensure the previous layer is totally dry, then change to the size 3 brush and lay in a second wash over the central petals of the rose. Start in the darker recesses of the petals, and draw the extremely watery wash outwards to the edges of the petals.

Note

When in doubt about where to draw the paint out to, always preserve the highlights. Colour can be added later, but it can not be taken away.

3 Still using the extremely watery permanent rose and the size 3 brush, begin to develop the shapes of the middle petals in the same way. Again, work from the recesses outwards, letting the paint run out before reaching the highlight areas. These petals curl up and are more shaped than the others, so be particularly careful to suggest their shape with the application of these washes.

4 Repeat the process on the outer petals. The veins are particularly noticeable on these petals, so it is important to follow the direction of growth. While the highlights here are a darker tone than those on the central petals, it is still important to isolate them at this point.

Note

You can apply the same pale wash over the whole rose, excluding the highlights, at this stage. This is because the whole rose is of sufficiently similar hues that this wash will not create an unwanted visual mix with the layers of paint that will be applied on top.

Stage 3 – Darkest tones

Working on the darkest areas next can feel a little wrong when you are not used to the process, as it makes the painting look very disjointed. It does, however, provide you with a visual anchor point on the paper of the darkest colour in the painting. With this in place, as well as your highlights preserved, it is far easier to make the sorts of tonal assessments needed when working on the midtones.

Consistency and hues

It is common not to take these areas as dark as is required, but do try to get the paint as thick as it should be to match the darkest tone in any composition. In the majority of flower subjects there will be areas of buttery consistency through to creamy as there are here, though this will depend on how dark the hues you are using actually are. For the rose here, I worked with my base hue of permanent rose and added burnt sienna to make it more orange, darker, and also duller. These are both dark hues and so to match the darkest tones in the rose I used them at a creamy consistency.

At this stage, the creamy paint is only applied to the very darkest areas. These are marked 'B' on the black and white photograph for this exercise. To recreate the smooth visual texture in these areas, I use a combination of the stippling technique and wash brush techniques to apply the thick paint smoothly (see page 53). Carefully compare your painting with the one below to make sure you are not taking this thick paint into areas of the rose that are lighter.

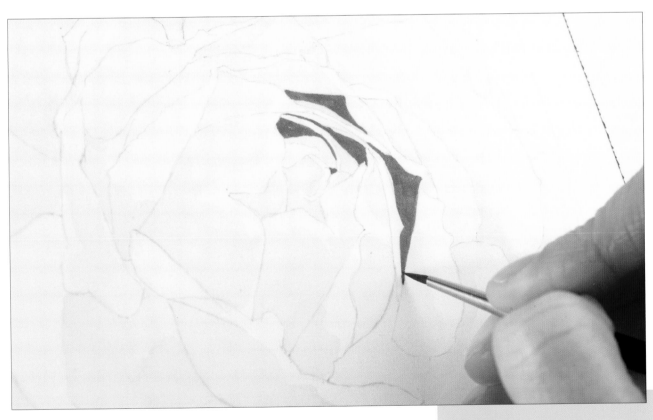

5 Ensure the previous layer is totally dry, then begin to place the darkest tones using the size 0 brush and the dark mix (permanent rose and burnt sienna) at a creamy consistency. Restrict this colour to the areas you are certain are the very darkest, creating neat hard line edges with the tip of the brush.

Note

Permanent rose and burnt sienna are naturally dark, so there is no need to use the mix at a thicker consistency.

Stage 4 – Midtones and contrast

You now have your lightest and darkest areas in place and can concentrate on the midtones and making visual tonal assessments of contrast levels. This stage is about gradually darkening the darker and lighter midtones. The gradual nature of the process minimises the risk of taking any one area too dark.

Consistency and hues

As we look at these midtones we can see at least two different hue areas. The centre of the rose is a more pink-purple, and the outer petals are duller, containing more greys and even yellow. We need to work on the midtones in those areas separately.

Inner petals – pink-purple hues

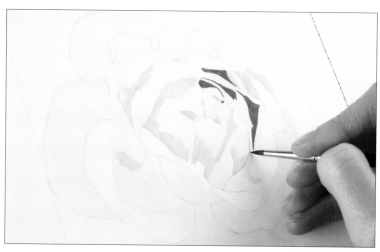

Note
Throughout this stage, remember to apply paint only when the previous layer is totally dry.

6 Make a mix of cobalt violet with touches of scarlet lake and a hint of opera rose. Dilute this to a watery consistency. This is our lighter midtone mix, but to apply it we begin in the darker midtone areas of the inner and middle petals as shown. Use the size 1 brush and, as with the first washes, start from the recesses and draw the colour out towards the highlights areas, following the shapes of the petals.

Note
Some of the dark areas as we move out towards the edge of the rose are left unpainted at this point, because they have a different hue (slightly more yellow). These will be added later.

7 Having started applying in the darker midtones, you can now see what the mix looks like on the paper and can apply it everywhere that is of similar hue and is this tone or darker. Refer closely to the monochrome rose on page 59 for guidance.

8 Using the same brush and mix, overlay some parts of the lighter midtones established in step 7. This second layer will darken the tone already in place to create some darker midtones. Carefully evaluate which particular areas of the midtones need darkening further. You are aiming to create a natural transition between the tones and also to add some visual texture to the transition into the previous layer, recreating the sorts of markings on the petals.

9 Make more of the dark mix (permanent rose and burnt sienna), then add a little cobalt violet. Dilute this to a consistency between milk and cream to create a mix that sits between the darkest tones and the lighter midtone mix you have just been applying. This is the darker midtone mix. Apply it to areas of that tone so as to bridge the gaps between the darks and lighter midtones.

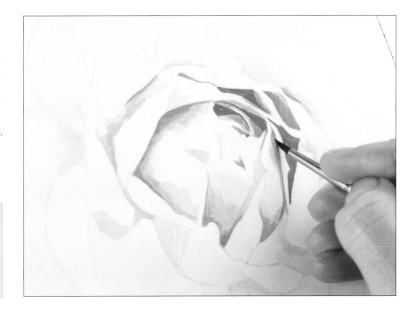

Tip
Do not worry if you miss a particular area. It can be added to, built up or altered as you work.

10 Now that you have darkened the darker midtones it is easier to see how much darker to take the lighter midtones. Make the lighter midtone mix of watery cobalt violet with touches of scarlet lake and opera rose. Change to the size 3 brush and use the mix to place the lighter midtones. Check the reference picture often and work conservatively: avoid lighter areas if you are not certain the tone needs to be changed. Use the size 1 brush for the lighter midtones in the centre.

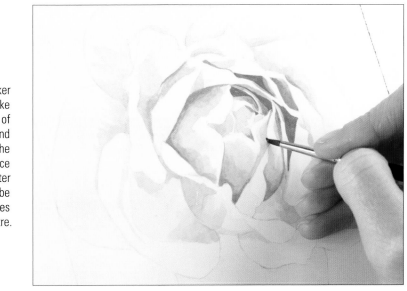

11 Lay a second wash of the same mix over the lighter and midtone areas where needed to strengthen the tone and soften the transition between the lighter and darker midtones.

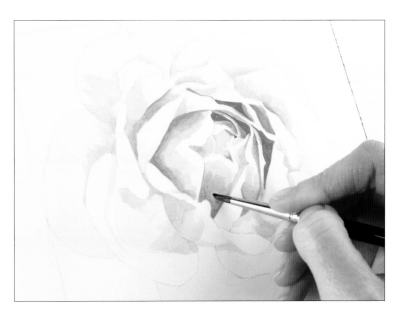

Outer petals – grey-pink and yellow-pink hues

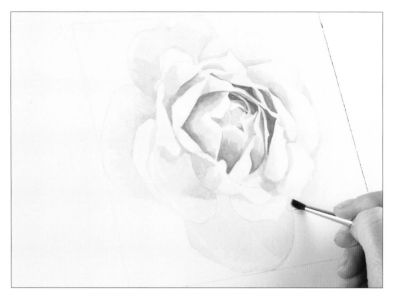

12 Begin to work on the next hue group. Mix a tiny quantity of Payne's gray with cobalt violet and dilute to a very watery consistency. This is your lighter midtone mix for this hue area. Using the size 3 brush, begin by applying the paint to the darkest areas of this hue area (the recesses). As before, suggest the direction of growth by drawing the paint outwards from the recesses to the edge. These outer petals have a more rough visual texture than the inner petals, so develop hard line edges (see page 54) by overlapping the colour a little. Work with a smooth stippling technique (see page 51) where required.

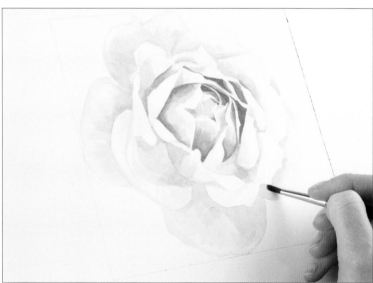

13 Add a little more cobalt violet and overlay the wash to develop the colour in the outer petals. Build up graduated edges (see page 52) to ensure a smooth transition in tone.

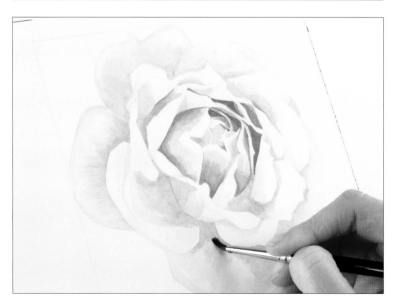

14 For the darkest recesses of the outer petals, build up the mix to a milky consistency, then add a little yellow ochre. This is your darker midtone mix for the grey-pink petals. Apply it to the darkest parts of these petals, creating graduated edges where it transitions into your previous layers.

15 Create a darker midtone mix for the yellow-pink hue area from cobalt violet, yellow ochre and a touch of Payne's gray, at a milky consistency. Still using the size 3 brush, apply the colour to the recesses of the yellow-tinged areas and draw the colour outwards to create graduated edges that blend the hue into the paint already on the paper. Darken the colour with another dilute layer over the same area, paying careful attention to the reference picture so the graduated edges build up in tone correctly.

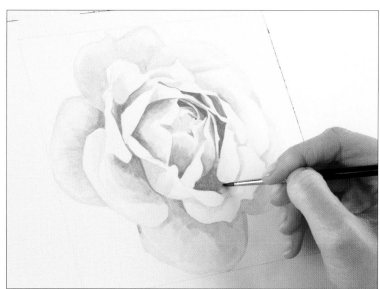

16 Now that you have taken the darker midtones of these hue areas darker, it is easier to assess how dark you now need to take the lighter midtones of these areas. Make more of the pink-purple lighter midtone mix (a watery mix of cobalt violet with touches of scarlet lake and opera rose). Use this with the size 1 brush to further develop the midtones of the inner and middle petals. This layer is an opportunity to work into any unwanted hard line edges and soften them to graduated edges. Thicken the mix to a milky consistency and use the tip of the brush for slightly darker areas in the very centre.

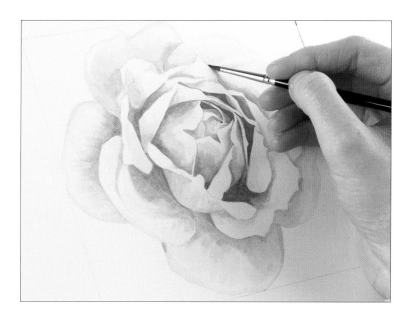

17 Begin to assess the levels of contrast in the piece as a whole and use the same watery pink-purple lighter midtone mix alongside the watery grey-pink lighter midtone mix to develop the transitions between the lighter midtones and the highlights.

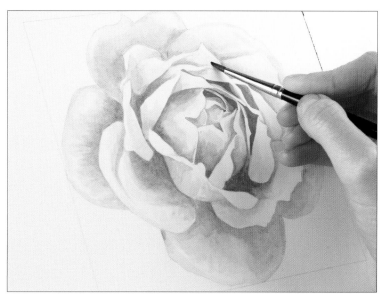

Stage 5 – Reassess highlights and hues

This stage is an opportunity to re-assess the highlights and hues on the painting. Once you have developed your midtones to the correct depth of tone, you will need to re-assess your highlights.

Assuming the initial washes applied in stage 1 were sufficiently watery, they will probably now appear a little too light, in which case you may need to take a very watery wash over them to darken them slightly. That will, in turn, lead you to want to deepen some of the dark tones and midtones to make them darker still. Again, as in stage 4, you are assessing contrast throughout the painting.

It is also at this stage that you may want to correct the hue of an area, or even the whole flower. For example, if your painting could do with being a little more permanent rose, then take a very thin watery wash of that hue over any areas that need it. Again, as with all the previous stages, always ensure the previous layer is totally dry before applying these corrective washes.

Note

The steps on this page are simply an example of reassessing the highlights and hues on my painting. They explain the particular changes I needed to make to get the correct hue and tone of paint. Your picture will require slightly different adjustments. Compare your work to the reference closely to see where you need to make your adjustments.

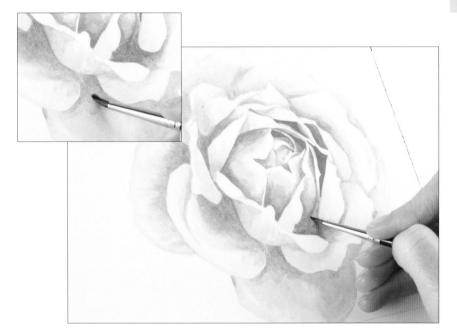

18 Change to the size 000 brush and use a milky mix of cobalt violet and Payne's gray to mute the darkest areas (see inset). Change to a size 1 brush to overlay the yellow areas with watery Winsor lemon.

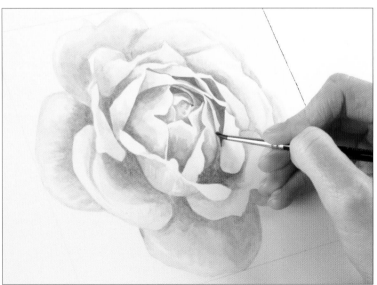

19 Use watery cobalt violet to deepen any highlights that need to be made slightly darker.

Stage 6 – Details and contrast again

The finishing touches always include defining the details a little more, as often they have been a little lost under all the many layers and corrective washes. In the case of the rose, the main detail is the hard line edges to the petals, and I now use a small brush to go over and neaten those edges with a suitable consistency of wash to match the tonal value of the particular petal.

In addition I used the same brush with a watery mix to paint in the vein marks visible on the outer petals. This detail work, together with the darkening of the highlights (stage 5) constitutes an overall darkening of the painting and may lead you to see that you need to deepen the tone in the darkest areas still further. If so, always take the time to make those corrections – these final details make all the difference to the realism of the piece.

Far from needing to know when to stop, then working in this way, you often need to know when to carry on. You know when you have finished because, even after a break away from your work, you will be unable to spot any significant differences in tone or hue between your painting and your subject. It is surprising how long this stage can take, but it always repays the effort.

20 Using the size 000 brush and a pink-purple mix of cobalt violet and scarlet lake, neaten the edge of the inner petals by working the colour in carefully to establish harder lines of contrast. Using the hues appropriate to the area, develop the rest of the petals in the same way to sharpen their edges.

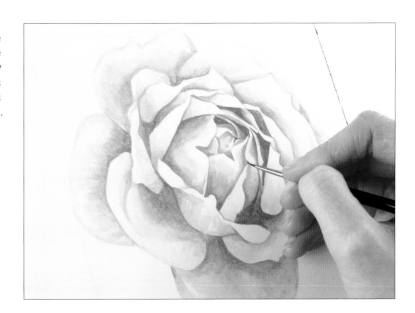

21 With the tip of the size 000 brush and mixes of the appropriate hue and tone for the individual petal, begin to emphasise the curve on the inner and middle petals by adding in subtle veins with the hard line brush technique (see page 54). The shaping you added in stage 4 will help to guide your brushstrokes.

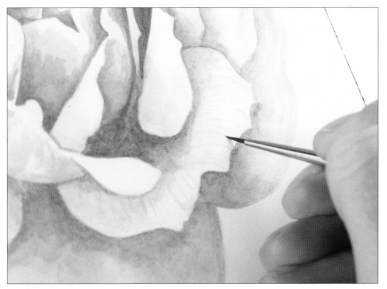

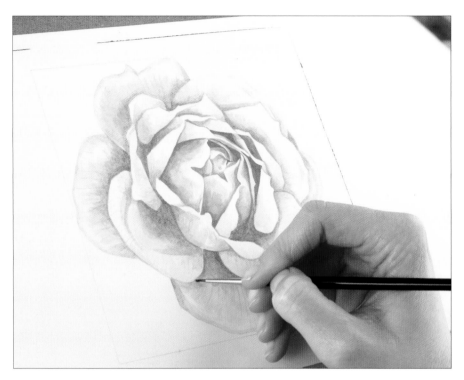

22 Use the grey-pink lighter midtone mix (watery Payne's gray and cobalt violet) to add the veins over the outer petals with the same technique. Although the veins are more obvious on the outer petals, do not over-emphasise them. Follow the direction of the earlier brushstrokes to suggest the petals' shapes to finish the painting.

Moving on

As you experiment and work through the projects in this book, you will discover that what is really important is that the highlights are put in place first, and preserved. This is why I always tackle stages 1 and 2 in that order. The order in which you work the other stages are not quite so critical to a successful piece.

It may often feel more comfortable to skip stage 3 and go straight into working on the midtones with the plan of building up to working on the darkest tones. However, as explained on page 29, hue and tone are relative. Without your darkest tones in place on your painting, it is always a lengthy process to gradually build up to the depth of tone required in the darkest parts, and very often people tend to stop short of getting as dark as they need to.

Because achieving the full tonal range is so important to get a three-dimensional appearance, I think it is really important to practise working on your darkest tones at stage 3 of your painting, and I will stress that throughout the following flower portrait projects.

The flower portraits will also show you how, when there are very different separate hue areas within a painting, you will need to work through the stages separately for each hue area. But, because hue and tone are relative and must be judged across the whole painting, any separate hue areas must all be brought on to the end of stage 4 before stages 5 and 6 can be completed for any hue area.

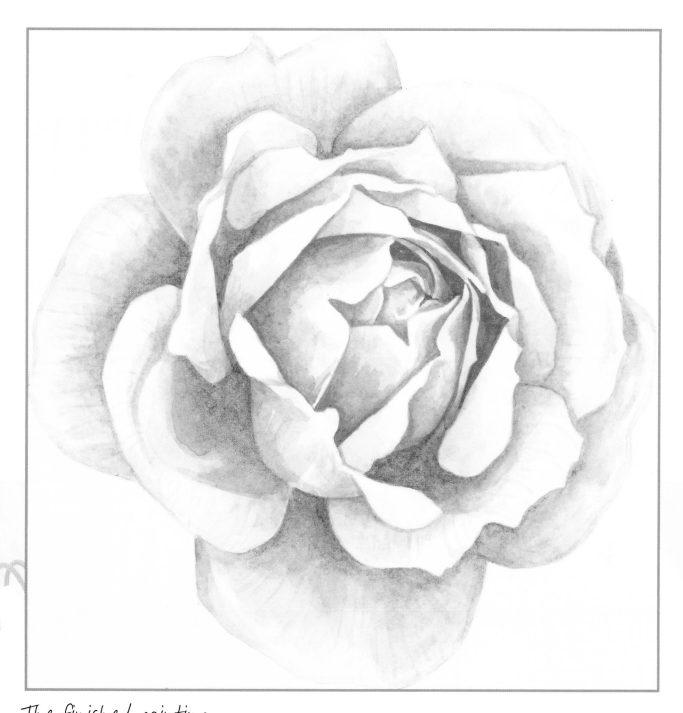

The finished painting

Here you can see that by getting the full tonal range in our painting – from the lightest lights to the darkest darks – we have achieved a three-dimensional effect so that our rose appears alive and sitting on our page.

Flower portraits

The flower portraits on the following pages form a series of six projects for you to try yourself. The portraits increase in difficulty so I suggest you attempt them in order if you are new to painting in this style. The first three are suited to beginners and the final three are better suited to those with a little more experience – but all the instructions are there so it is great practice even if you have less experience.

A final image of my finished painting is supplied with each portrait and I suggest you use this as your main reference material for your own painting, to be supplemented with the step-by-step photographs supplied. I detail every stage of each painting and include full notes on hue mixing as well as brush technique. I also include swatches of the different mixes I used to show you both the hues and the sort of consistency of paint with which I was working. You could use my finished painting in each case and create your drawing from it using the technique shown on pages 24– 25. However, to assist you with drawing, there are outlines provided at the back of the book for you to trace or measure and draw if you wish.

The portraits cover a good range of hues so that you gain experience working with the main hue groups. They also show you how to tackle the different sorts of stamens found in flowers, various different sorts of patterns as well as several key types of flower leaf, which I know can often be tricky for students to master.

The more challenging and complex the portraits are, the longer they will take to do. Everybody works to their own pace with this type of painting but I have offered an estimate of how long each portrait might take in the introduction for each one to give you some guidance on how long you can expect it to take.

For each portrait I draw your attention to the area of greatest contrast within the painting, which is important to get right as this is where the eye tends to be drawn to within the piece. I supply you with a greyscale tonal image of the painting too. You can refer to this to help you to focus on tone and achieve the full tonal range within the portrait so that you can get those three-dimensional effects!

Fiery Poppies
These oriental poppies remind me of a flickering fire with their feathered petals.

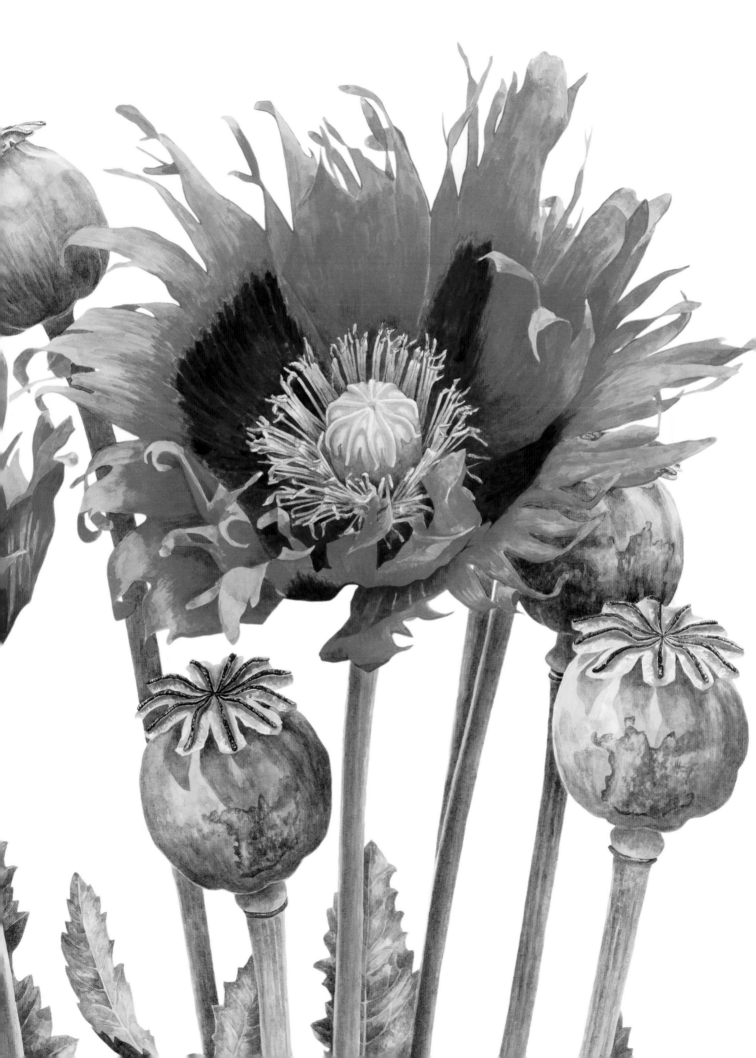

Clematis

This flower, *Clematis viticella* 'Madame Julia Correvon' is dark and bright, so this is an exercise in achieving strong depth of colour with plenty of variation in hue while still retaining some light tones so that the flower does not look flat.

The area of greatest contrast in this painting is clear cut – the stamens are so light in tone compared with the petals that the eye is strongly drawn there. It is therefore vital we get the stamen edges crisp, and the contrast as strong as it should be.

This painting should take you between four and six hours, and can be completed within one day. As with all of the projects in this book, it is important to allow each layer of paint you apply to dry fully before you apply the next.

You will need

Watercolour paper: 300gsm (140lb), white, Hot Pressed finish, 18 x 25.5cm (7 x 10in)

Watercolour paints: permanent rose, scarlet lake, opera rose, permanent alizarin crimson, quinacridone red, bright violet, cobalt violet, Payne's gray, Davy's gray, Winsor lemon, permanent sap green, olive green

Paintbrushes: size 000, size 0, size 3

HB pencil and eraser

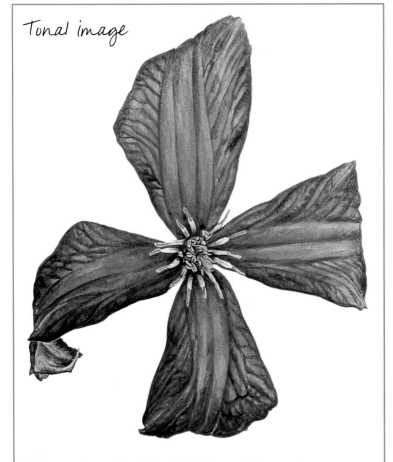

Tonal image

This greyscale version of the finished artwork shows the strong contrast between the stamens and the surrounding petals and makes it clearer which veins are darkest. It also shows us that the bottom and left-hand petal are darker than the other two, particularly at the edges where they curl under.

Drawing

The main part of the drawing involves getting the stamens in the right place and making sure that you have outlined them so that you can fill them in with your paint.

I also included the main veins on the petals as getting the angles of these right is what gives the petals their form and stops them from looking flat.

1 Following the instructions on pages 24–25, lightly reproduce the outline on page 124 on your watercolour paper.

Painting

Stage 1 – Highlights

Our stamens are our highlights so we begin with them.

2 Apply a watery mix of Winsor lemon to the tips and to the centre. Use a 000 brush to get plenty of control and stay within the pencil lines.

3 Once that is dry, use Davy's gray at a milky consistency at the base of the stems by the centre, creating a graduated edge as you apply it outwards from the centre of the stamens.

Stamen mixes

Watery Winsor lemon Milky Davy's gray

Stage 2 – Isolating the highlights

To isolate the stamens we want to get a base wash down on our petals. As usual we want to try to match this wash to the lightest tone within this hue area.

4 Use a size 3 brush to apply a milky consistency wash of permanent rose to the main bodies of the petals.

5 Add a little cobalt violet to the wash and water it down a little before applying it to the underside of the left-hand petal.

6 Work carefully with a size 0 brush to apply the mix around the stamens.

Note

You can see that I have ended up with a lot of accidental hard edges. I have applied the paint in the direction of the veins so the overlap marks I am creating at this stage are actually helpful in creating form. Make sure you do this with every wash you apply to the petals.

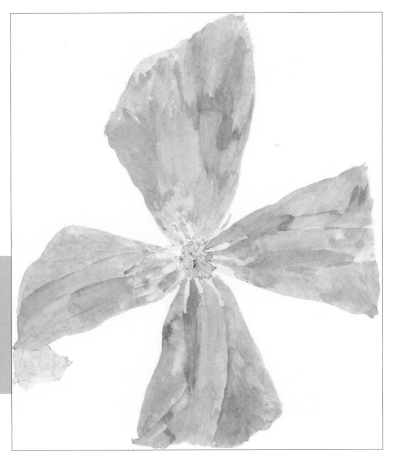

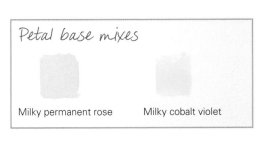

Petal base mixes

Milky permanent rose Milky cobalt violet

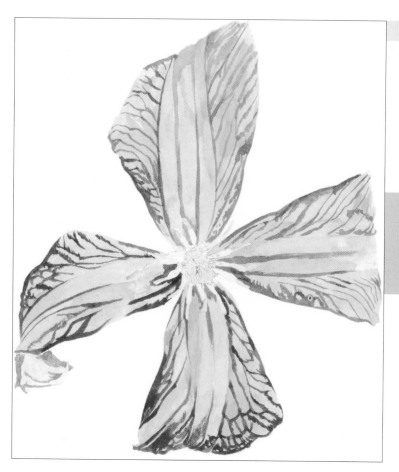

Stage 3 – Darkest tones

7 Mix permanent rose with hints of permanent alizarin crimson and bright violet to form a creamy consistency and apply it to all the very darkest areas – which will mean applying it to a lot (but not all) of the veins. Use a size 0 brush.

8 Water the mix down slightly as you work on the top and right-hand petal to match the tone of the veins there.

Note

Strictly speaking this leads into stage 4 (midtones and contrast). The more experienced you get, the more you are going to combine stages 3, 4 and 5 intuitively as you paint.

Petal dark mix

Creamy permanent rose with hints of permanent alizarin crimson and bright violet

Stage 4 – Midtones and contrast

Mix a colour to match the lightest tones within the petals by mixing a milky version of opera rose, scarlet lake, quinacridone red and permanent rose.

9 Use a size 3 brush to begin to apply the wash to the darkest parts of the petals where you can be confident that it will not be too dark. As you see exactly how the mix appears on the paper, make a careful tonal judgement and apply it to everywhere that is the same tone and darker. Use a wash technique and apply the paint with a light touch so as not to lift the dark vein marks underneath too much. If your wash is sufficiently pale you should be able to apply it everywhere except the underside of the left petal. Vary the proportions of the different hues a little to match the subtle changes in hue present in the petals, especially towards the tips.

First petal midtone mix

Milky opera rose, scarlet lake, quinacridone red and permanent rose

Stage 4 continued – Midtones and contrast

Once dry, you can go through the process again, applying another layer. Pay attention to the way that the tone is subtly darker towards the stamens (where there is more shadow) and also at the edges of the petals – this additional layer will definitely be applied here, but not in the slightly lighter areas.

10 At this point begin to pay more careful attention to the hue. Use some milky cobalt violet with opera rose as you work on the edges of the topmost and right-hand petals. Add some more quinacridone red wherever the hue is more red.

Second petal midtone mix

 Milky cobalt violet, opera rose and quinacridone red

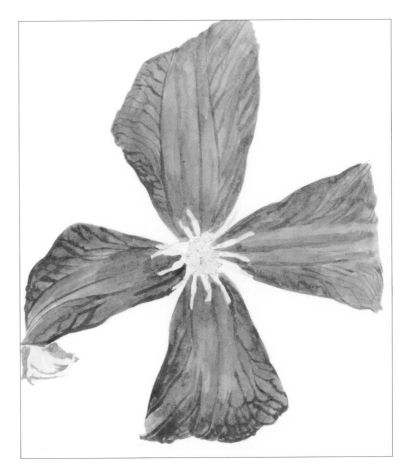

Stage 4 continued – Midtones and contrast

Having been working on the lighter midtones, it becomes clear at this stage how much darker we need to take the dark tones. We have also lost definition on our veins because we have been putting washes over the top.

11 Apply the dark mix (permanent rose with hints of permanent alizarin crimson and bright violet) at a creamy consistency to any areas of the petals which are that tone or darker using a size 0 brush. This will mostly be to the veins again.

12 This makes the contrast look too strong so we have to take the light or midtones a little darker. Return to the size 3 brush and use your milky wash of the first midtone mix (opera rose, scarlet lake, quinacridone red and permanent rose) and again build up the areas that need to be darker, adjusting for hue as you do so by changing the hue ratio in your mix.

13 Add in a mix of bright violet with scarlet lake to the parts of the petal that need a darker tone and more purple hue.

Third petal midtone mix

 Bright violet and scarlet lake at a consistency between milk and cream

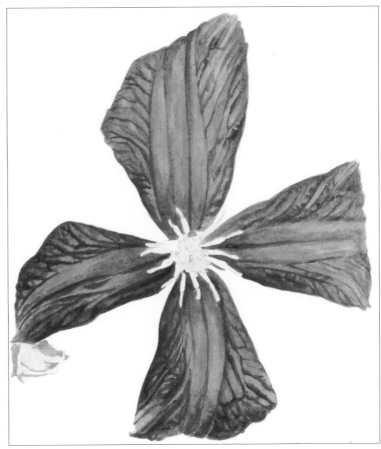

Stages 5 and 6 – Reassess highlights and hues, details and contrast

Although you will have been correcting your hues all the way along, this is the time to add in a wash to correct hue in an area if it is needed.

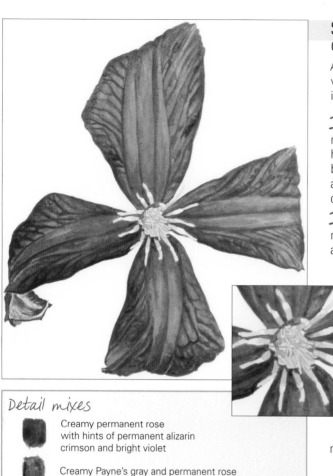

14 Repeat steps 12 and 13 until the petals are dark enough. You may need to do this more or less depending on how dark your layers have been. In turn this lets us see that the darkest tones need to be darkened further. Work on the veins using a size 0 brush and a creamy mix of permanent rose with hints of permanent alizarin crimson and bright violet.

15 Use a 000 brush to outline the stamens with the dark petal mix: a creamy mix of permanent rose with hints of permanent alizarin crimson and bright violet.

16 Still using the 000 brush, add Payne's gray to permanent rose to create a darker hue. Use this to create the detail on the curled-over petal and to darken further the veins on the rest of that petal.

17 Apply milky Davy's gray to the outer stamens with a size 000 brush. Begin at the base of each and work your way out so that you naturally run out of paint towards the tips and create graduated edges on the transition to the lighter colour.

18 Use a milky mix of Davy's gray, Winsor lemon and olive green, with the size 000 brush, to pick out the midtone shapes within the central stamens (see inset).

Detail mixes

Creamy permanent rose with hints of permanent alizarin crimson and bright violet

Creamy Payne's gray and permanent rose

Milky Davy's gray, Winsor lemon and olive green

Stage 6 – Details and contrast

Now that the petals are looking dark enough, we can work on the detail in the centre of the flower. Once this is done, you can assess the whole painting's contrast levels again.

Detail mixes

Creamy Davy's gray and permanent sap green

Creamy permanent rose with hints of permanent alizarin crimson and bright violet

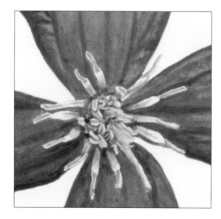

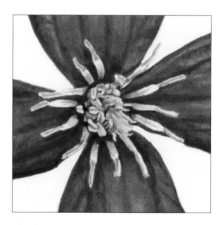

19 Use a creamy mix of Davy's gray and permanent sap green to pick out the darkest shapes within the stamens in the centre using a 000 brush. To get this kind of detailed control it is important to use the paint fairly creamy. But the tone here is not very dark which is why a hue which is itself quite light, such as Davy's gray, is really useful.

20 Once these are darkened, you can again assess the contrast and will likely see that the petal tone between and around the stamens needs to be darker. Use a very thick (buttery) mix of permanent rose with hints of permanent alizarin crimson and bright violet to apply a final layer around the stamens which serves to really define them and draw the eye to them.

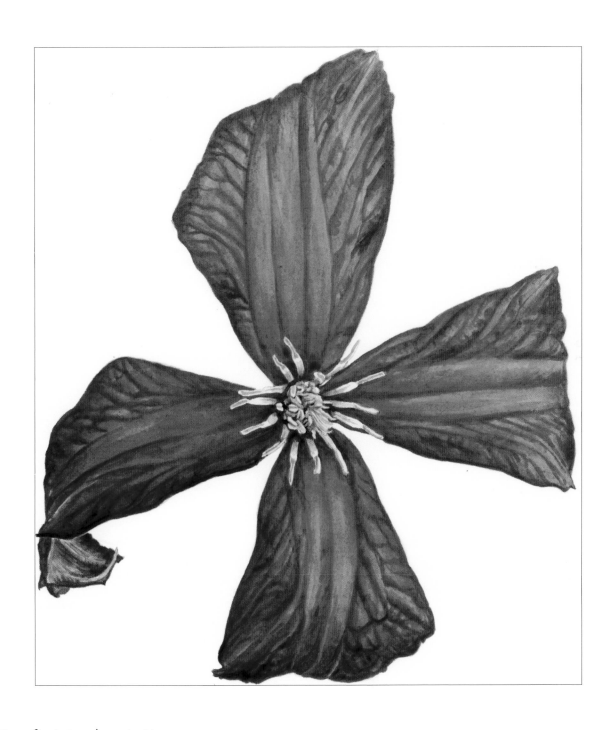

The finished painting

*This gorgeous dark flower has a clear and striking form,
which is enhanced by the prominent veining.*

Viola

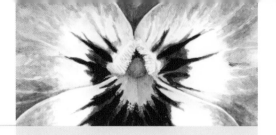

This little wintertime gem is a beautiful blue. As an exercise it allows us to focus on creating patterns and using the stippling brush technique to achieve rough visual texture on the petals. It is a great example of how first impressions can deceive. At first glance you might simply think it is blue, but when you really look there are a multitude of subtle variations in hue and tone within those petals. Replicating those variations will be what makes our painting look realistic.

The areas of greatest contrast are where the very dark blue striped markings meet the white petal around them, and also the very dark centre of the flower which is surrounded by hairy-looking white markings. We need to focus on these areas when we are checking we have our tonal balance correct.

This portrait should take around four or five hours to complete, so it is achievable in a day.

You will need

Watercolour paper: 300gsm (140lb), white, Hot Pressed finish, 18 x 25.5cm (7 x 10in)

Watercolour paints: French ultramarine, bright violet, olive green, Winsor lemon, translucent orange, Payne's gray, burnt sienna, Davy's gray, permanent sap green, yellow ochre, cobalt blue, olive green

Paintbrushes: size 5, size 3, size 1, size 0, size 000

HB pencil and eraser

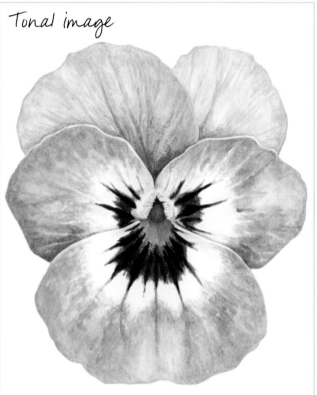

Tonal image

The clear distinction between the dark of the pattern in the centre of the flower and the light areas around it is obvious in this greyscale version of the finished artwork. It also allows us to more easily see the way that the petals are darker where they sit behind other petals.

Drawing

The drawing includes the outside edge of the petals and the main shapes at the centre of the flower, including the dark blue stripes. It is tempting to create another outline where the transition takes place from the white in the lower three petals to the pale blue towards the edge of the petals. However, if you look closely, that transition is actually very rough and does not form a smooth line. Because this transition is from such a light hue (white) we do not want to risk having our pencil line there visible. As a result, it is best not to put a pencil line in there, but to mark that shape out in paint when we get to that stage.

1 Following the instructions on pages 24–25, lightly reproduce the outline on page 125 on your watercolour paper.

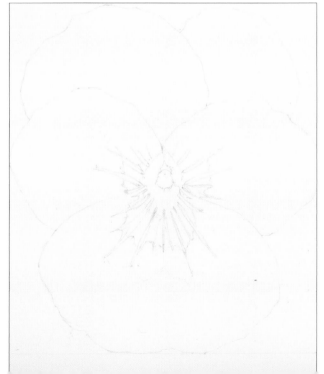

Painting

Petals stages 1 and 2 – Highlights and isolating the highlights

Our highlights are the white parts on the lower three petals, which have a rough transition into the outer blue parts. Other key highlights are the white markings that create an outline edge to the upper edges of the lower three petals and the hairy-looking parts to the centre of the two middle petals. All these highlights are so white that we need to isolate them by painting around them and leave them as clean paper.

The rough visual texture of the blue parts of the petals means there is a mix of lighter and darker hues and a very uneven application of paint will be required to reproduce the effect. We therefore need to begin by laying down a wash that matches the lightest possible tone within the petals.

2 Dilute the petal highlight mix to a very watery consistency and apply to the upper two petals using a size 5 brush. Use a wash brush technique for a relatively smooth finish.

3 Use the same brush to apply the mix to the lower three petals with the stippling technique. Work in the direction of growth (i.e. from the centre of the flower outwards). Leave little gaps in your paint where there are white striped markings on the petals and make plenty of stippling marks at the transition between the blue and white parts. Make sure you leave the line of white along the top of the middle two petals to avoid a smooth, hard line edge where the two hue areas meet.

Centre of flower stage 1 and 2 – Highlights

Turning to the other hue areas at the centre of the flower, we need to get a highlight mixture down on these. The yellow hue area is a particular highlight and by working around it with the darker blue highlight we will isolate it and make sure we preserve it as we continue to paint.

4 Use a 0 brush to apply extremely dilute olive green to the hairy light areas around the very centre of the flower.

5 Use a 0 brush to apply a mix of Winsor lemon with a hint of translucent orange at a consistency between milk and cream over the yellow area, being careful not to extend it into the areas of the blue stripes. If you do this you may end up with an undesirable green hue when you work on your blue stripes.

6 Add a tiny amount of Payne's gray to the yellow mix you were using in step 5. The result will be a muted green hue of the same consistency. Apply this with a 0 brush to the very centre part of the flower.

7 Mix French ultramarine with hints of bright violet into a milky consistency. Use a 000 brush for precision and apply a wash over the dark blue pattern area. It can be applied over the whole of this area, including over what will be the very darkest stripes within that area.

Petal highlight mix

Very watery mix of French ultramarine with hints of bright violet

Centre of flower highlight mixes

Extremely watery olive green

Winsor Lemon with hints of translucent orange, between milk and cream in consistency

Winsor lemon with hints of translucent orange and Payne's gray, between milk and cream in consistency

Milky French ultramarine with hints of bright violet

Centre of flower stage 3 – Darkest tones

The darkest tones within the portrait are the navy, almost black-blue stripes on the lower three petals, so we need to get those painted next to offer us the visual anchor point on the paper.

Darkest tones mixes

 Payne's gray with hints of bright violet at a creamy consistency

 Equal parts French ultramarine and bright violet at a consistency between milk and cream

8 Create a creamy mix of Payne's gray with hints of bright violet. Use a size 000 brush to apply it where required. The shapes have hard line edges so work to create a neat edge to them.

9 Still using the size 000 brush, darken up the next-darkest tones in the dark blue hue area with a mix of French ultramarine and bright violet between milk and cream in consistency. Use the tip of your brush to create a rough visual texture at the transition from blue to white, and blue to yellow, and leave small gaps there to allow the lighter layer of paint applied in step 7 to show through to help with that rough transition. Finally apply the mix to the base of the top left petal, above your white highlight line.

Petals stage 4 – Midtones and contrast

Always work in the direction of the markings you see on the petals – so from the centre of the flower out towards the edges, or from the edges of the petals in towards the centre.

By the end of this stage, the lighter midtones will have been taken darker which will make it easier to see that the darker midtones need to be darker still.

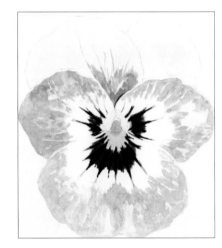

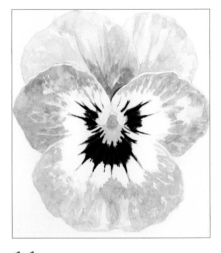

Darker midtone mixes

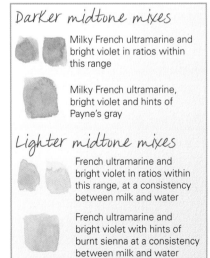 Milky French ultramarine and bright violet in ratios within this range

Milky French ultramarine, bright violet and hints of Payne's gray

Lighter midtone mixes

French ultramarine and bright violet in ratios within this range, at a consistency between milk and water

French ultramarine and bright violet with hints of burnt sienna at a consistency between milk and water

10 Use a size 3 brush and the stippling technique to apply the darker midtone mixes of French ultramarine and bright violet to the lower three petals and the base of the top left petal. Vary your mix by altering the ratios of French ultramarine and bright violet to try to capture some of the hue variation present in the petals.

11 Still using a size 3 brush, use the lighter midtone mixes of French ultramarine and bright violet to concentrate on the top two petals. Use a wash brush technique to apply the paint to create the somewhat smoother visual texture we see there.

12 Make sure the lower petals are dry. Using the darker midtone mixes, and adding in a touch of Payne's gray where a darker, more muted hue is required, use the size 3 brush and the stippling technique to continue to darken up the darker midtone areas.

Note

Now that the darker midtones have been taken darker we can see that in my painting the lighter midtones need to also be taken darker. Assess whether this is the case with your own painting.

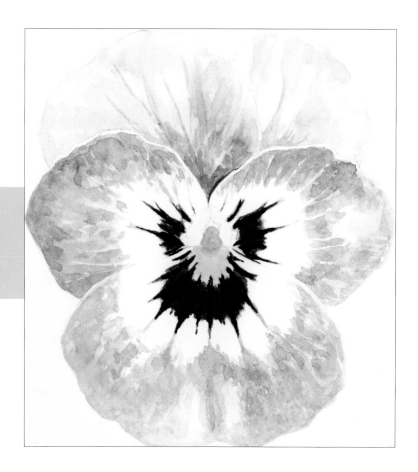

13 Add a touch of burnt sienna to the mix of French ultramarine and bright violet wherever a more muted, and more red hue is required. Work on both the upper and lower petals where required, ensuring that the previous layers you have applied are dry.

14 Use the darker midtone mixes (see opposite) with a size 1 brush to start to create a little more of the detail in the markings on the petals. Use the tip of the brush to create line detail where required.

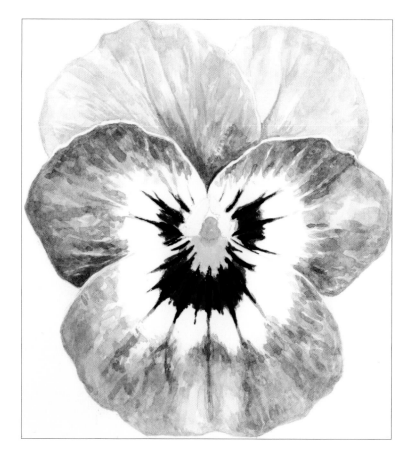

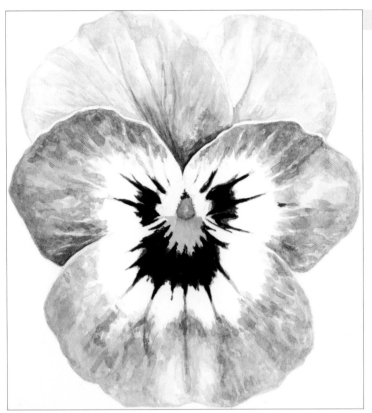

Centre of flower stage 4 continued – Midtones and contrast

Now that we have worked on the midtones, we can assess the contrast levels in the piece. In mine, I can now see that the dark blue pattern area needs to be darkened further.

15 Make a mix of French ultramarine, bright violet and Payne's gray that is between cream and butter in terms of consistency. Use a 000 brush to apply this over most of the dark stripes again, where required. Then water the mix down to a milky consistency and extend it a little into the slightly lighter dark-blue patches around the stripes.

Dark stripes mix

French ultramarine, bright violet and Payne's gray in a consistency between cream and butter

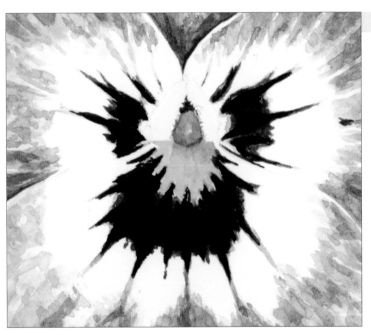

Centre of flower stages 3 and 4 continued – Darkest tones, midtones and contrast

In order to check the tonal range of the piece as a whole, we now need to get the very dark details in the centre of the flower painted.

16 Create a mix of olive green with hints of Payne's gray at a consistency between milk and cream. Using a size 000 brush, use the mix to pick out the line detail around the green part of the centre, including picking out little lines into the white areas around it, to create more hair-like definition there.

17 Still using the size 000 brush, work on the midtones in the green centre, as well as the lines coming into the yellow area using a mix of permanent sap green, Winsor lemon and olive green in a consistency between milk and cream.

18 Use a mix of Payne's gray and burnt sienna in a creamy consistency to pick out the dark area above the green centre with your size 000 brush.

19 Use the size 000 brush to pick out darker parts of the yellow area with a creamy mix of yellow ochre with hints of burnt sienna.

20 Finish off the yellow area with a layer of neat Winsor lemon where required. This will help to naturally blend in and create a graduated edge between the yellow ochre mix and your original yellow mix.

Flower centre darkest tones and midtone mixes

 Olive green with hints of Payne's gray at a consistency between milk and cream

 Permanent sap green, Winsor lemon and olive green in a consistency between milk and cream

Creamy Payne's gray and burnt sienna

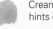 Creamy yellow ochre with hints of burnt sienna

Neat Winsor lemon

Stages 5 and 6 – Reassessing highlights, plus hues and details

Now that we have darkened the centre, we are in a position to reassess the highlights.

21 Apply the petal highlight mix (as used in step 1) to areas of the petals that need to be a little darker, using a size 3 brush and the stippling technique.

22 Use the same brush and layer on top of any of your previous stippling marks that look a little too prominent – this will help to smooth the visual texture. Also focus on the transition area between the white and blue parts of the lower petals to make sure the transition looks to be gradual, but has plenty of rough visual texture.

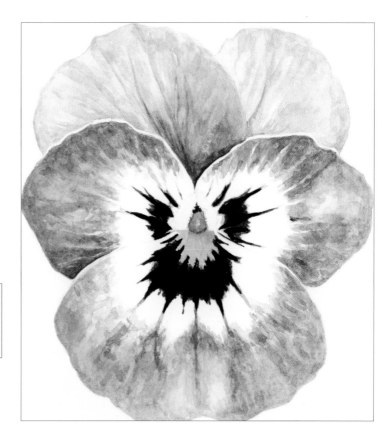

> *Petal highlight mix*
> Very watery mix of French ultramarine with hints of bright violet

White petal area stage 4 – Midtones and contrast

As you work on the white areas on the petals, pay particular attention to the area behind the bottom petal. As you build up grey there, you create contrast between the white outer edge of the bottom petal and the two petals behind. This has the effect of making the bottom petal appear to sit in front of the others.

23 Use some creamy Davy's gray to create tiny lines within the white parts around the green centre.

24 Dilute the mix to a watery consistency and add a hint of Payne's gray. Apply this mix as a wash over some parts of the white area of the flower using the size 0 brush. Vary the amount of water in your mix to match the tones you see.

> *white petal area mixes*
> 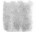 Creamy Davy's gray
> Watery Davy's gray with a hint of Payne's gray
> Very watery Davy's gray with a hint of Payne's gray

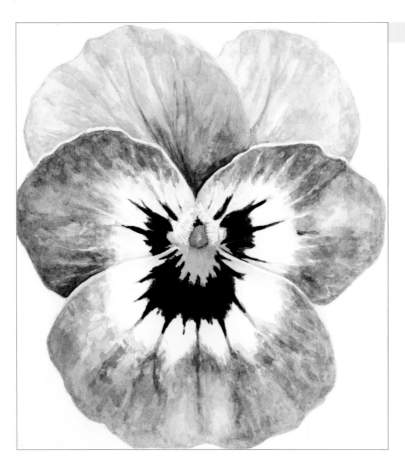

Stages 5 and 6 continued – Reassessing highlights, plus hues and details

These stages develop details like the veins and develop the petal edges, adding the finishing touches for realism. Once these are completed, check whether any final corrective hue washes are necessary.

The image to the left shows the picture before the finishing touches. Compare it with the picture below to see the subtle changes.

25 Use the mix from step 15 (French ultramarine, bright violet and Payne's gray) and a 000 brush to create tiny dots on the yellow area of the flower, next to the dark blue stripes.

26 Use the mix from step 11 (French ultramarine and bright violet) in a milky consistency, with your 000 brush to draw in more of the visible veining on the top petals, as well as to define the edges of your petals.

Darkest tone mixes

 French ultramarine, bright violet and Payne's gray in a consistency between cream and butter

 Equal parts French ultramarine and bright violet at a consistency between milk and cream

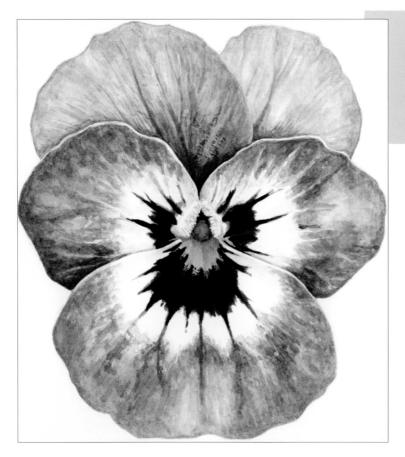

Note

At this final stage I always make a final assessment of the tones and hues in my paintings. In this case I decided that in some of the lighter parts of the upper two petals I needed to add a little blue to brighten them. You will need to assess if your painting also needs this.

27 Use neat cobalt blue in a consistency between milk and water and apply to the areas required using a size 3 brush. Use a wash technique and a light touch with your brush so that the wash sits on top of your previous layer and does not disturb the detailed vein work created previously.

28 Finally, darken the very centre of the flower – and the yellow area if required – by using the size 000 brush with the flower centre darkest tones and midtone mixes (see page 82).

Hue corrective wash mix

Cobalt blue in a consistency between milk and water

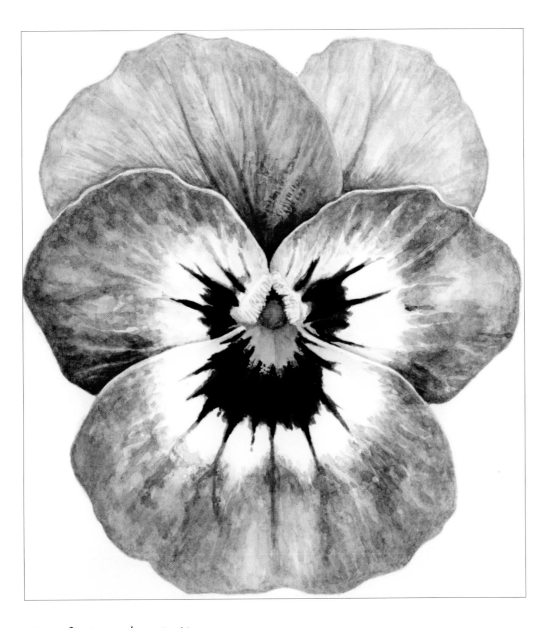

The finished painting

*This viola is bold in its pattern, but the visual texture on its petals
also makes it seem delicate.*

Cosmos

Shown from a side-on angle, this bright summer annual provides a great opportunity to create three-dimensional effects through tone. The petals themselves contain both tonal variation and a lot of creases and veins, which require using the tip of the brush to create hard line edges.

This painting uses several hues that are themselves dark in tone, so we will be using them fairly dilute and building up numerous milky layers to the correct depth of tone. In the process we will be building in lots of the visual texture on the petals, to avoid creating a flat-looking flower. You will also see how working with milky washes means you do not need to worry about creating unwanted hard edges because the edges naturally blend as you apply further layers.

This portrait is a lot of fun to do and will give you a real flavour of painting in this style. It is also significantly larger than life, so it is that bit easier to capture all the details. The area of greatest contrast is where the very dark markings at the base of the petals meet the yellow centre of the flower. There are also other significant areas of high contrast within the petals themselves, especially where they curl and overlap. Close attention must be paid to these areas as we judge whether our tonal balance is correct.

This portrait should take around four to five hours to complete.

You will need

Watercolour paper: 300gsm (140lb), white, Hot Pressed finish, 25.5 x 18cm (10 x 7in)

Watercolour paints: Winsor lemon, opera rose, cobalt violet, permanent rose, bright violet, Payne's gray, burnt sienna, permanent alizarin crimson, translucent orange, Davy's gray, olive green

Paintbrushes: size 5, size 3, size 1, size 0, size 000

HB pencil and eraser

Drawing

For this drawing I have drawn in the outline edges of the petals and only the most prominent of the veins/ creases within the petals. I have created an outline edge to the yellow flower centre and have also marked in the prominent outer stamens. I have even blocked the lengths of the stamens in with pencil. This is so they are easier to see and, because those stamens are black in colour, I know I will be using paint dark enough to cover the pencil markings. I have also outlined some of the shapes within the yellow centre, to make it as easy as possible to paint them.

Tonal image

This greyscale version of the finished artwork shows just how much darker the area around the centre of the flower is when compared to the rest of it, as well as how dark the stem is. It also shows the darker shapes on the petals created by shadows as the petals fold and curl next to each other.

1 Following the instructions on pages 24–25, lightly reproduce the outline on page 125 on your watercolour paper.

Painting

Stages 1 and 2 – Highlights and isolating the highlights

By far the brightest highlight in this portrait is the yellow centre, so it is important that we put the lightest yellow from within that hue area down first. Although that yellow centre is clearly defined by pencil, it always helps to isolate the highlights with paint early on.

To isolate the highlight, we can apply the lightest colour we see within the pink petal areas to the whole of the petals. It is then clear where the boundaries of the highlight are. Do not be concerned about any hard line edges that may be created at this stage.

2 Apply a wash of milky Winsor lemon to the centre area with a size 0 brush. Pick out the tips of the stamens around the edge too.

3 Dilute an opera rose and cobalt violet mix, that matches the hue and tone of outer edges of the pink petals (i.e. the lightest areas), to a consistency between water and milk. Apply this to the petals using a size 3 brush and work in the direction of the veins/creases in the petals – from the centre of the flower outwards, or in towards the centre. Leave three gaps under the yellow centre where the hue will be very dark.

Highlight mixes

Neat Winsor lemon at a milky consistency

Opera rose and cobalt violet at a consistency between water and milk

Petals stage 3 – Darkest tones

The darkest tones of the whole portrait are the very dark brown shapes around the yellow centre. However, to create the pink of the petals, we are going to be working with milky mixes of paint, whereas the dark brown shapes will require a thick, buttery paint. If we laid down the dark buttery paint before working with the wetter paint on the pink petals we risk the dark paint bleeding into the wet pink paint as we apply it.

To avoid the risk of this happening, while still achieving the full tonal range, focus on the darkest tones within the pink petals first.

4 Mix permanent rose, cobalt violet and hints of bright violet to a consistency between milk and cream, then apply it using a size 3 brush to the very darkest areas.

5 Water the mix down to a milky consistency and apply the paint, following the directions of the veins/creases as you work. Use the tip of the brush to create hard line edges where required. Where a smooth transition between hues will eventually be required, make lots of little lines with the tip of your brush to create feathered edges to the shapes.

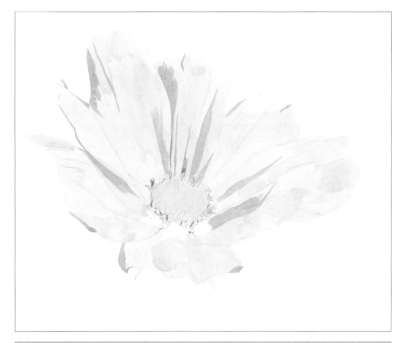

Petal darkest tone mixes

Permanent rose, cobalt violet and hints of bright violet at a consistency between milk and cream

Permanent rose, cobalt violet and hints of bright violet at a milky consistency

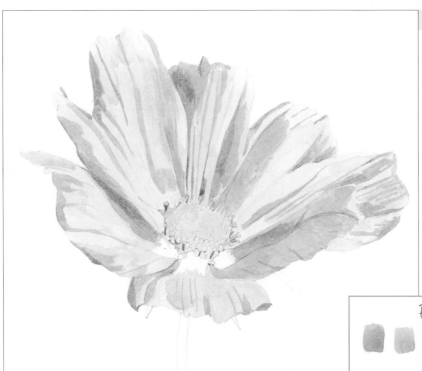

Petals stage 4 – Midtones and contrast

With the darkest tones on the petals established, focus on the next darkest colours within the petals. Apply the mix to an area you know to be dark first. Judge how it looks on the paper, and use this as a guide when applying it to areas of the petals that are this colour or darker.

6 Using a size 3 brush, apply mixes of permanent rose, cobalt violet with hints of Payne's gray to the midtones of the petals while following the directions of the veins. Keep the consistency of the mixes between water and milk and vary the ratios of the paints between the ranges shown.

Petal midtone mix 1

Permanent rose, cobalt violet with hints of Payne's gray at a consistency between water and milk – vary the hue ratios within this range

Petals stage 4 continued – Midtones

Now that the dark tones are taking shape, it shows just how light our light tones within our petals are. Because tone is relative, as you start applying the wash in step 7 to the petals it becomes clear that the darkest tones will need to be darker.

For this reason, apply this wash over the top of the darker-toned parts of the petal to darken those areas too and help smooth their hard line edges.

7 Create a mix of opera rose and cobalt violet and apply it to the whole of the petals in the direction of the veins using a size 5 brush. Vary the consistency of the paint from watery to between water and milk in order to match the tones you see in the petals.

8 Use a milky mix of permanent rose with cobalt violet and hints of Payne's gray to darken the darkest areas further. Apply the paint to the darkest areas of the petals with a size 3 brush, using the tip where required to create hard line edges.

Petal midtone mix 2

Opera rose and cobalt violet at a consistency between water and milk and at a watery consistency.

Petal midtone mix 3

Permanent rose, with cobalt violet and hints of Payne's gray, at a milky consistency

Petals stage 4 continued – Midtones and contrast

The following steps explain the subtle adjustments to be made. As you darken the dark midtones, it becomes clear that the lighter midtones need to be taken darker too. In turn, as the lighter midtones are darkened, we need to focus again on darkening the darker midtones.

This process of progressively darkening and refining the midtones continues until it becomes impossible to judge how to darken the petals correctly without the dark brown shapes at the base of the petals being in place.

9 Use the petal midtone mix 2 (see opposite) at a consistency between water and milk to apply the lighter midtones. Use a size 3 brush and use the tip to create lines to start creating some of the veins on the petals.

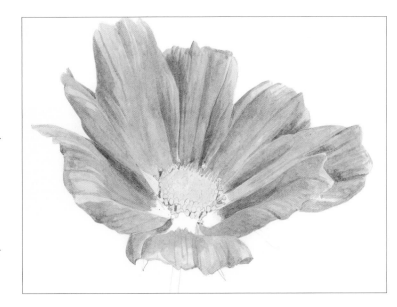

10 Use a size 3 brush to apply a milky mix of permanent rose, Payne's gray and cobalt violet to the darkest areas, using the tip of the brush to create lines where appropriate.

Petal midtone mix 4

 Permanent rose, Payne's gray and cobalt violet at a milky consistency

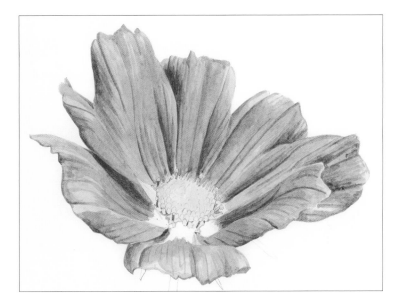

11 Create a mix of opera rose, cobalt violet and hints of permanent rose at a consistency between water and milk. Apply the paint using a size 3 brush, and always in the direction of the veins/creases.

Petal midtone mix 5

 Opera rose, cobalt violet and hints of permanent rose at a consistency between water and milk. Vary the amount of permanent rose within this range.

Note

At this stage I know I want to darken the darkest parts of the petals again, but without the dark brown shapes at the base of the petals in place (the darkest tones in the whole composition), it is not possible to judge how much darker they should go. So, next we need to work on those dark parts of the petals.

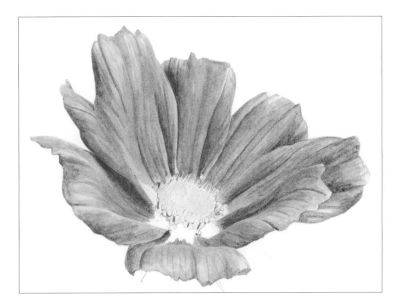

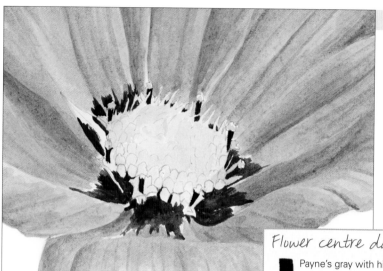

Flower centre stage 3 – Darkest tones

12 Create a mix of Payne's gray with hints of burnt sienna at a buttery consistency and apply it to the black parts of the stamens around the edge using the tip of the size 000 brush.

13 Add permanent alizarin crimson to the mix and water it down to a creamy consistency. Apply this to the darkest areas at the base of the petals, again using the size 000 brush. Where it meets the pink hue, paint edges to the shapes with plenty of lines to create a feathered look. This will help to create a graduated – but visually textured – transition into the pink petals.

Flower centre darkest tones mixes

 Payne's gray with hints of burnt sienna at a buttery consistency

Payne's gray with hints of burnt sienna and permanent alizarin crimson at a creamy consistency

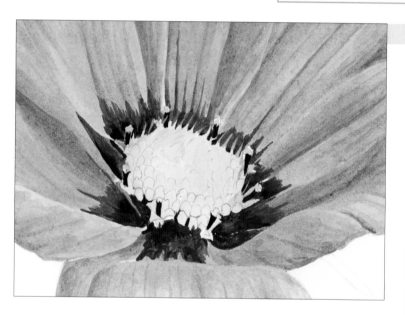

Flower centre stage 4 – Midtones and contrast

14 Create a mix of burnt sienna with permanent alizarin crimson and hints of Payne's gray at a creamy consistency and apply with a size 000 brush in the same way as in step 13. Allow the colour to overlap the previous, darker colour, helping to create a graduated transition between the colours.

15 Use a mix of translucent orange and burnt sienna at a consistency between milk and cream to pick out any paler, more orange shapes with a size 000 brush, including to the spiky shapes coming out of the top of the centre.

Flower centre midtone mixes

 Burnt sienna with permanent alizarin crimson and hints of Payne's gray at a creamy consistency

 Translucent orange and burnt sienna at a consistency between milk and cream

 Bright violet and permanent rose at a consistency between milk and cream

16 Using a size 000 brush, apply a mix of bright violet and permanent rose, at a consistency between milk and cream, to the transition between the previous colour laid down and the pink petal. Overlap the previous layer to help create a graduated transition.

Flower centre stage 4 continued – Midtones and contrast

With the darkest tones established, we can now work on the lighter midtones within the flower centre which will further darken the centre overall.

17 Using a size 000 brush, apply a creamy mix of neat Winsor lemon over the centre, leaving the very lightest areas.

18 Still using the size 000 brush, apply a milky mix of Winsor lemon with burnt sienna and Davy's gray to the bases of the shapes around the lower edge of the flower centre.

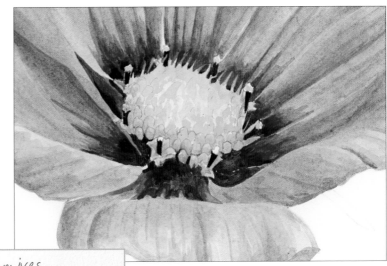

Flower centre additional midtone mixes

■ Creamy Winsor lemon		■ Milky Winsor lemon with burnt sienna and Davy's gray	
■ Creamy Winsor lemon with hints of olive green		■ ■ Milky burnt sienna, Davy's gray with hints of Winsor lemon, in different proportions	

19 Use a creamy mix of Winsor lemon with hints of olive green to pick out some midtone shapes with the size 000 brush.

20 Still using the size 000 brush, darken the bases of many of the lower shapes within the flower centre with a milky mix of burnt sienna, Davy's gray and hints of Winsor lemon. Vary the proportions of each hue within the mix.

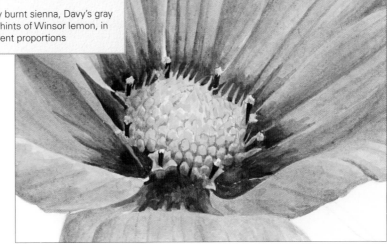

Flower centre stage 6 – Details, plus Sepal and stem details stage 1 – Highlights

21 Create a mix of Winsor lemon, translucent orange and burnt sienna at a milky consistency and use a size 000 brush to pick out the 'hair-like' details on the flower centre as well as applying to the transition from the dark parts of the petals to the pink parts.

22 Use a mix of Payne's gray, permanent alizarin crimson and burnt sienna in a consistency between milk and cream to further darken the brown parts of the petals with a 000 brush. Use this same mix and brush to apply this mix to the stem and dark parts of the sepals, because it matches the lightest colours we see there.

Additional mixes

■ Milky Winsor lemon, translucent orange and burnt sienna		■ Payne's gray, permanent alizarin crimson and burnt sienna in a consistency between milk and cream	

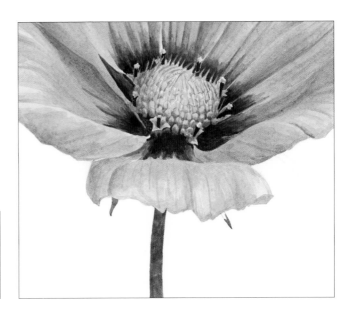

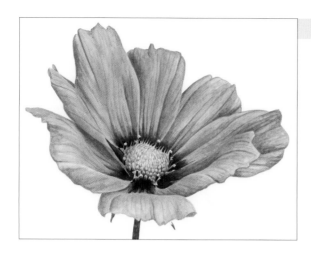

Petals stage 4 continued – Midtones and contrast

With the centre as dark as required, we can now revisit the petals, darkening them to the correct hue and tone.

23 Use a mix of bright violet and permanent rose, at varying consistencies between watery and milky within the range shown. Apply to the darkest parts of the pink petals, this time with a size 0 brush, using the tip where necessary to create lines of veins/creases.

Petal mixes:

Bright violet and permanent rose, at varying consistencies between watery and milky within this range

Watery opera rose with hints of cobalt violet

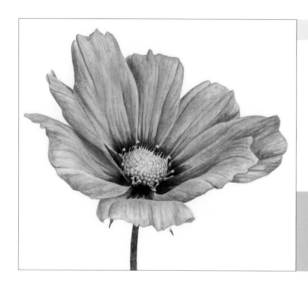

Petals stage 5 and 6 – Reassess highlights and hues, and details

We can now darken the highlights if required and, in turn, the darkest tones of the petals to balance.

24 Apply a watery mix of opera rose with hints of cobalt violet over the highlights and wherever the hue needs to be brightened with a size 3 brush.

25 Use a size 000 brush and the milky mix of bright violet and permanent rose to add line details to the veins and petal edges.

Note

As so often happens, working on the details caused the lightest areas to look too light in comparison, so I needed to darken them to get the contrast correct. You will need to judge for yourself whether your painting needs this stage.

26 f necessary, use a size 1 brush to apply the watery opera rose with hints of cobalt violet mix to darken any areas of the petals that seem too light.

Whole painting stage 6 – Details and contrast

27 Apply a watery mix of olive green with Payne's gray to the right two sepals with a size 000 brush.

28 With the same brush and a mix of burnt sienna, Payne's gray and olive green at a consistency between milk and cream, apply the darkest parts of the right two sepals.

29 Use a creamy mix of Payne's gray with hints of burnt sienna and permanent alizarin crimson and a 000 brush to add a stippled layer to the stem (leave plenty of gaps), and also to pick out dark details around the centre.

30 Use the bright violet and permanent rose mix at a consistency between milk and cream to pick out any further details on the pink petals.

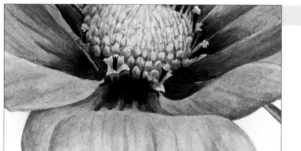

Details mixes:

Watery olive green with Payne's gray

Creamy Payne's gray with hints of burnt sienna and permanent alizarin crimson

Burnt sienna, Payne's gray and olive green at a consistency between milk and cream

Bright violet and permanent rose at a consistency between milk and cream

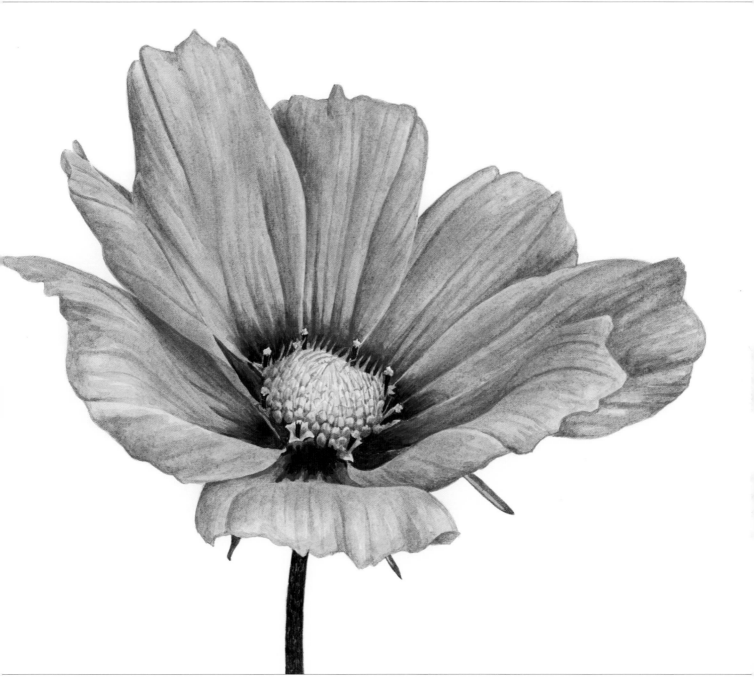

The finished painting

We can feel that this cosmos is likely to flutter in the breeze. It has movement and shape to it – all of which is created by getting our tonal balance correct.

Tulips

This painting is complex because of the variety of hues involved. Each different area of hue must be tackled independently as you work through each of the six stages (see pages 58–69). It gives you an opportunity to focus on mixing your own blacks and greys, as well as achieving the darkest tones with watercolour.

The area of greatest contrast is where the light parts of the petals at the front of the flowers are set against the very dark hues on the inside of the petals, and where the flowers meet the stems.

As always, throughout this project, allow each layer of paint you apply to dry fully before you apply the next. The tulips should take you between ten and fifteen hours, over two or three days.

Tonal image
This greyscale version of the finished artwork shows just how dark the insides of the petals are, as well as the lines on the feathered edges of the petals. It also makes it clear how much tonal variation must be painted into the stem to make it look cylindrical.

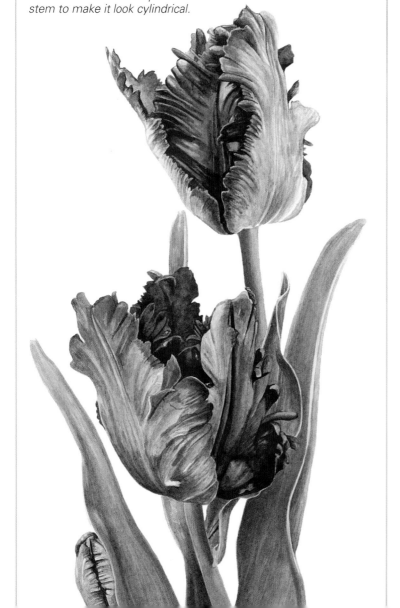

You will need

Watercolour paper: 300gsm (140lb), white, Hot Pressed finish, 18 x 25.5cm (7 x 10in)

Watercolour paints: permanent alizarin crimson, Payne's gray, burnt sienna, permanent rose, cobalt violet, bright violet, quinacridone red, permanent carmine, quinacridone magenta, opera rose, yellow ochre, permanent sap green, Winsor lemon, cobalt turquoise light, olive green, Winsor blue (green shade)

Paintbrushes: size 5, size 3, size 1, size 0, size 000

HB pencil and eraser

Drawing

Because the painting has the potential to be confusing with all the different hues, make sure your drawing provides a strong foundation to work from with plenty of detail.

1 Following the instructions on pages 24–25, lightly reproduce the outline on page 126 on your watercolour paper.

Painting

Stages 1 and 2 – Highlights and isolating the highlights

There are so many different hues in this composition that it is potentially confusing. To avoid this, combine stages 1 and 2 and apply a layer of the lightest tone within each hue group straight away. Start with the flowers and, once dry, move on to the other major hue group: the green stems and leaves. This allows you to see immediately what is going on in terms of hue.

2 Refer to the image on the right to apply washes of the flower highlight mixes (below) to the petals, using the tip of the brush to create any necessary hard line edges shown. Use a size 3 brush for larger areas and a size 1 where you need more control. Even at this stage the paint should be applied in the direction of the markings on the petals to start to create the impression of curves and shape.

3 Paint the bud in the same way using the bud highlight mixes, then paint the leaves and stem with watery washes of the mixes below right. Where there is a lot of yellow hue at the end of the leaves, start with almost pure Winsor lemon as a wash.

Note

The darker-hued shapes in the centre of the petals do not really contain tones this light, but applying this wash to those shapes serves to isolate the shapes of highlight tones on the petals. It is here that you will probably need to use a size 1 brush.

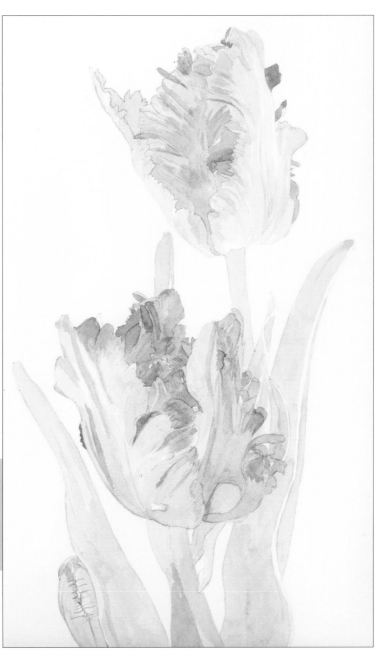

Flower highlight mixes

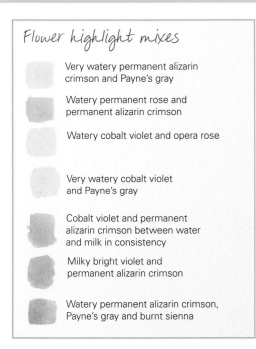

Very watery permanent alizarin crimson and Payne's gray

Watery permanent rose and permanent alizarin crimson

Watery cobalt violet and opera rose

Very watery cobalt violet and Payne's gray

Cobalt violet and permanent alizarin crimson between water and milk in consistency

Milky bright violet and permanent alizarin crimson

Watery permanent alizarin crimson, Payne's gray and burnt sienna

Bud highlight mixes

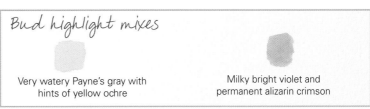

Very watery Payne's gray with hints of yellow ochre

Milky bright violet and permanent alizarin crimson

Leaf and stem highlight mixes

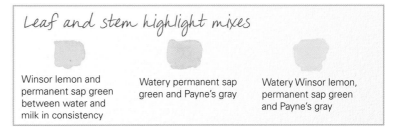

Winsor lemon and permanent sap green between water and milk in consistency

Watery permanent sap green and Payne's gray

Watery Winsor lemon, permanent sap green and Payne's gray

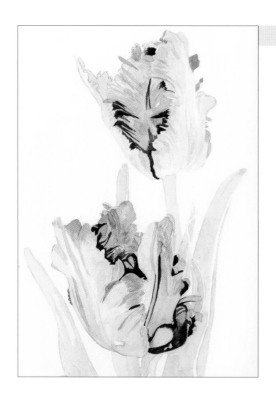

Petals stage 3 – Darkest tones

For this stage, restrict yourself to the very darkest tonal shapes. You can ignore the dark on the bud as it is not necessary for assessing contrast levels when working on the midtones on the petals.

4 Use size 1 and 0 brushes to apply the dark petal mix to the petals, creating hard line edges and thick washes as shown.

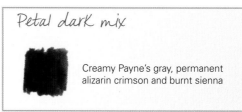

Petal dark mix

Creamy Payne's gray, permanent alizarin crimson and burnt sienna

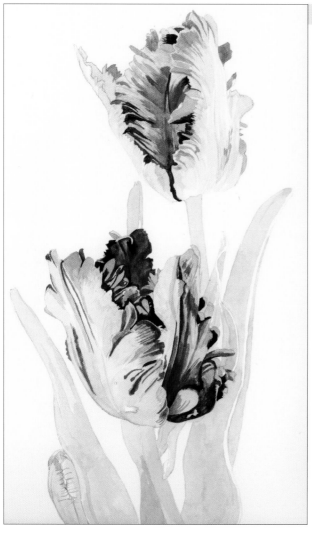

Petals stage 4 – Midtones and contrast

Mix your paint to match the hue and tone of the areas of the composition just lighter than the ones worked on during stage 3. Broadly speaking, this is the insides of the petals. There are several different hues within each of the petals so we need to treat each hue area separately. As you get more experienced you will learn to mix a hue and then vary its consistency (tone) as you work on a given hue area.

5 Work on the dark red/purple hues on the upper petals first using the top flower midtone mixes and the size 1 and 0 brushes. Once complete, paint the red-purple hues on the lower petals with the lower flower midtone mixes, which have further variation in hue.

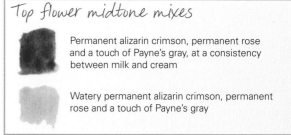

Top flower midtone mixes

Permanent alizarin crimson, permanent rose and a touch of Payne's gray, at a consistency between milk and cream

Watery permanent alizarin crimson, permanent rose and a touch of Payne's gray

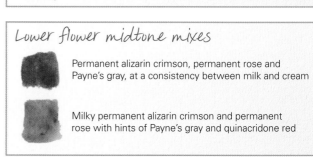

Lower flower midtone mixes

Permanent alizarin crimson, permanent rose and Payne's gray, at a consistency between milk and cream

Milky permanent alizarin crimson and permanent rose with hints of Payne's gray and quinacridone red

Petals stage 4 continued – Midtones and contrast

6 Water down the petal dark hue (see opposite) to a milky consistency to make the petal midtone mix below. Use this to start to bridge the gap between the darks laid down in stage 3 and the red hues we have just applied.

7 Vary the consistency slightly to match different tones. In particular, dilute the mix to a watery consistency for the outer petal.

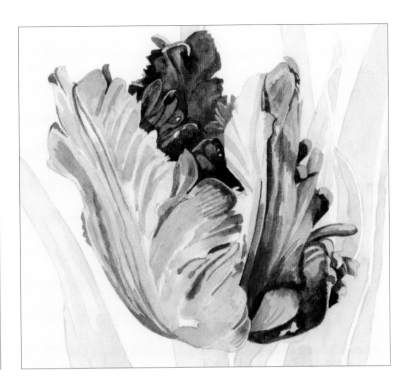

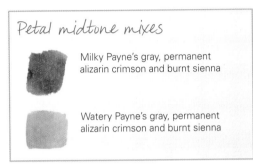

Petal midtone mixes

Milky Payne's gray, permanent alizarin crimson and burnt sienna

Watery Payne's gray, permanent alizarin crimson and burnt sienna

Petals stage 4 continued – Midtones and contrast

Now that the darker areas have been worked upon, it is easier to see how dark we will need to take the lighter parts of the outer petals, so we can concentrate on them now.

8 Using watery to milky washes of the hues below, develop the marks on the petals. The visual texture of the petals is fairly smooth and there are a mixture of hard line edges and graduated edges. We are working on a fairly small scale so use the size 1, 0, and 000 brushes.

Note

Create and use each mix one at a time. If you try and prepare them all in advance you will find they have dried out by the time you come to use them.

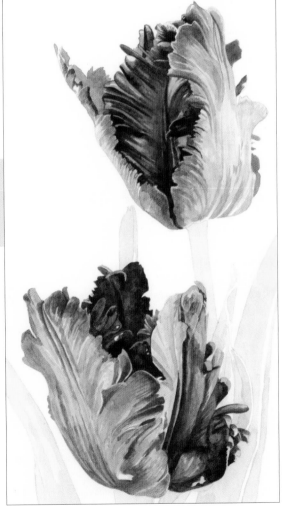

Outer petal midtone mixes

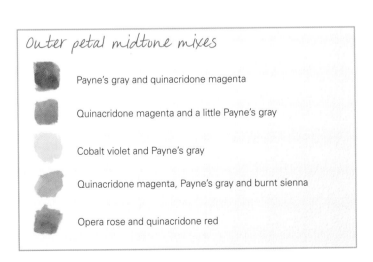

Payne's gray and quinacridone magenta

Quinacridone magenta and a little Payne's gray

Cobalt violet and Payne's gray

Quinacridone magenta, Payne's gray and burnt sienna

Opera rose and quinacridone red

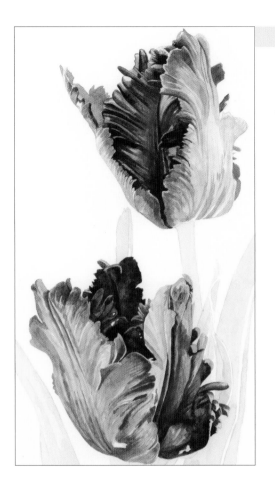

Petals stage 4 continued – Midtones and contrast

Now that the lighter areas have been taken a little darker, it allows us to better assess the contrast and see how much darker the dark areas need to be taken.

9 Use the petal dark mix below to work on the darker areas using a size 0 brush. Dilute the buttery mix to the consistency of milk for lighter dark tones. Where you need to make a really rich version of the dark hue, add in plenty of permanent alizarin crimson.

Petal dark mix

Buttery Payne's gray, permanent alizarin crimson and burnt sienna

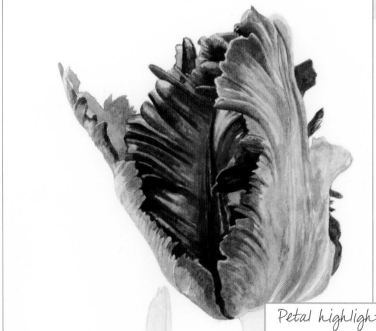

Petals stage 5 – Reassess highlights and hues

Now that the darker areas have been darkened further, the lighter areas can be adjusted further.

10 Pick out line details on the outsides of the petals of both flowers, using the size 0 brush with a mix of permanent carmine and quinacridone magenta between water and milk in consistency.

11 Again, working on the outsides of the petals, change to a size 1 brush to apply washes of a watery Payne's gray and cobalt violet mix where needed, then repeat the process using a mix of permanent carmine with hints of Payne's gray to pick out areas that feature that hue.

Petal highlights and hue reassessment mixes

Permanent carmine and quinacridone magenta at a consistency between water and milk

Watery Payne's gray and cobalt violet

Permanent carmine with hints of Payne's gray, at a consistency between water and milk

12 If necessary, use watery washes of the appropriate hue to alter your tulips. At this point I felt that mine needed the red parts to be brighter red, so I opted for watery washes of quinacridone red in the lighter red areas, and thicker washes of permanent carmine in the darker areas.

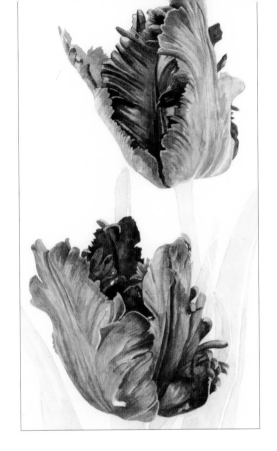

Stems and leaves stage 4 – Midtones and contrast

At this point we need to get our stems and leaves as dark as they should be. That will allow us to make the final assessment of contrast with our petals, to see if we have taken them dark enough. The key to achieving the correct depth of colour on the leaves is to build up several layers of watery paint, applied in lines, allowing each layer to dry completely in between.

13 Apply a watery wash with the leaf and stem mixes (these are the same colours and consistencies used in stage 1), to all but the lightest areas of the stems and leaves. Apply the paint in lots of hard lines in the direction of growth, to recreate the lines you can see on the leaves.

14 In the lighter blue-green parts of the stem and leaves, apply a mix of cobalt turquoise light and Winsor lemon at a consistency between water and milk.

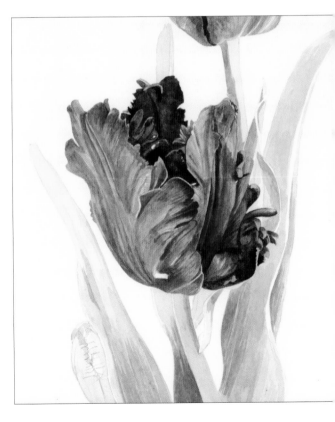

Leaf and stem mixes

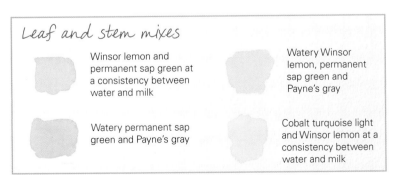

Winsor lemon and permanent sap green at a consistency between water and milk

Watery Winsor lemon, permanent sap green and Payne's gray

Watery permanent sap green and Payne's gray

Cobalt turquoise light and Winsor lemon at a consistency between water and milk

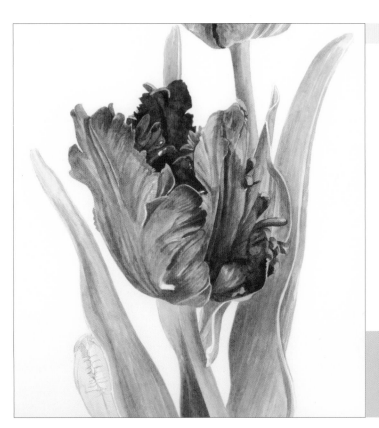

Stems and leaves stage 4 – Midtones and contrast

15 Using a size 1 brush, apply layers to the darker areas of the stems and leaves with a combination of permanent sap green, olive green and Payne's gray. Always work in the direction of the vertical lines on the leaves, and keep the paint fairly thick but flowing, at a consistency between milk and cream.

16 For the small brown area of leaf, use burnt sienna at the consistency of milk and apply it using a size 0 brush.

Leaf and stem midtone mixes

Permanent sap green, olive green and Payne's gray between milk and cream in consistency

Milky burnt sienna

Note

I worked on the darkest tones in the leaves as part of stage 4 here, because I already had the very dark tones in the petals serving as a visual anchor for how dark to take the midtones in the leaf.

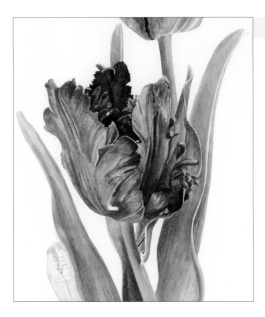

Stages 5 and 6 – Corrective washes and details

Once the leaves are darkened, you will be able to assess the contrast and see whether the petals need to be adjusted.

17 If necessary, adjust the petals, leaves and stems. In my case, they needed to be just a little darker in some areas, especially on the edges of the petals, so use the milky Payne's gray, permanent alizarin crimson and burnt sienna mix on the petals, and the leaf and stem mixes (see above) on the stem and leaves; applying them with the size 0 brush.

18 Work through stages 3–5 on the bud with the 0 and 000 brushes and using lots of line markings. Use the dark petal mix from step 9 and the petal midtone mixes from step 11 (Payne's gray and cobalt violet, and permanent carmine with hints of Payne's gray). Also use a milky mix of bright violet and permanent alizarin crimson where there is the darker purple hue.

19 If necessary, apply a corrective wash of Winsor lemon on the leaves and some watery Winsor blue (green shade) on the bottom right leaf. Apply a wash of the dark petal mix to the outer petals again.

Detail mixes

Milky Payne's gray, permanent alizarin crimson and burnt sienna

Buttery Payne's gray, permanent alizarin crimson and burnt sienna

Watery Payne's gray and cobalt violet

Permanent carmine with hints of Payne's gray, at a consistency between water and milk

Milky bright violet and permanent alizarin crimson

The finished painting

We really feel up-close to these tulips. This is partly due to the low angle of the composition, but also because of the rich deep colours that make it look so real and fresh.

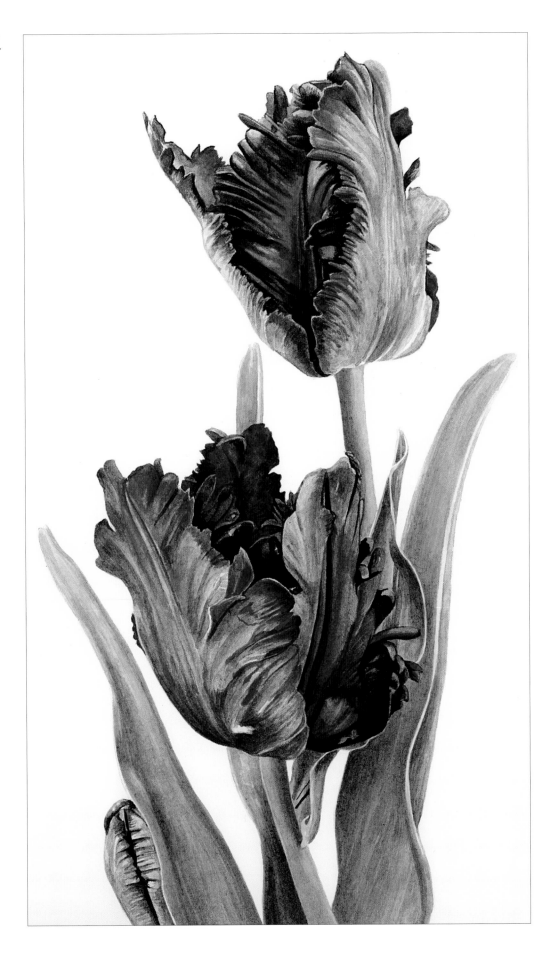

Oriental Poppy

This glorious, fiery poppy is both vivid and detailed. There are a lot of different hues, and a lot of fine detail to capture in this portrait. I have included it to offer you a challenge.

Focus on preserving the light coloured stamens and bright yellow-green centre – the stigma disc – against the dark inside of the petals. These are the areas of greatest contrast so it is important we try to get them looking right. In addition, concentrate on creating tonal variation on the raggedy edges of the petals so that they appear to have plenty of shape. The leaves and seed heads have a covering of bloom (a fine powdery coating sometimes found on fruit, leaves or stems) which gives us a good opportunity to recreate these effects in this portrait.

This portrait is likely to take you between ten and fifteen hours to complete, over two or three days.

Note
You may find you want to enlarge your version before you paint it in order to be able to more easily work on the detail. If you do, use brushes one size larger than that referred to in the steps. For example, substitute a size 1 where the step mentions a size 0, and a size 5 where the step mentions a size 3.

You will need

Watercolour paper: 300gsm (140lb), white, Hot Pressed finish, 18 x 25.5cm (7 x 10in)

Watercolour paints: cobalt violet, burnt sienna, Payne's gray, bright violet, Winsor lemon, Winsor green (yellow shade), olive green, opera rose, scarlet lake, translucent orange, permanent sap green, cobalt turquoise light, permanent carmine, permanent alizarin crimson, Davy's gray

Paintbrushes: size 3, size 1, size 0, size 000

HB pencil and eraser

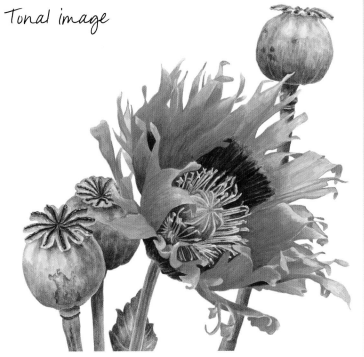

Tonal image

This greyscale version of the finished artwork shows how dark the dark central parts of the poppy petals are. It also makes it clear that there is a wide tonal range in the seed pods as well as the stems.

Drawing

The accuracy of the drawing is key to this portrait. Draw in the outline of every part of the flower, including each individual stamen, and also the little stripes (these are the stigma discs) on the top of the seed heads.

1 Following the instructions on pages 24–25, lightly reproduce the outline on page 127 on your watercolour paper.

Painting

Stamens and dark area stages 1 and 2 – Highlights and isolating the highlights

As there are so many details and different areas of hue to include, combine stages 1 and 2 straight away in order to get a layer of paint down everywhere, so you can see exactly what is going on in terms of hue areas.

2 Use a size 0 brush to apply the extremely watery cobalt violet with hints of burnt sienna and Payne's gray mix to the main lengths of the stamens (the filaments).

3 Use the same brush to apply the extremely watery burnt sienna and Payne's gray mix to the tips of the stamens (the anthers), as well as the area to the bottom left of the stigma disc.

4 Make a mix of bright violet with hints of burnt sienna and Payne's gray at a consistency between water and milk. Ensuring the stamens are dry, use a 0 brush to apply the wash to the very dark parts of the petals. Vary the ratios of the hues in the mixture to match the variations you see and work in the direction of growth – from the centre of the flower out towards the edges.

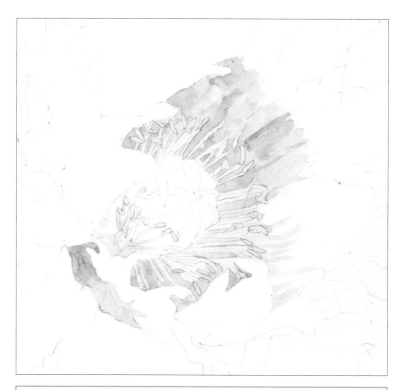

Stamens and dark area highlight mixes

Extremely watery cobalt violet with hints of burnt sienna and Payne's gray

Extremely watery burnt sienna and Payne's gray

Bright violet with burnt sienna and Payne's gray, with a consistency between water and milk

5 Dilute a mix of Winsor lemon with a touch of Winsor green (yellow shade) to a watery consistency. Use a size 0 brush to apply it to the whole of the stigma disc in the centre of the flower and also to the outside edges of the stigma discs on the seed heads. Leave a few areas on each without any paint as the lightest highlights.

6 Still using the size 0 brush, apply a milky mix of Winsor lemon with hints of olive green and Payne's gray to the base of the stigma disc in the flower.

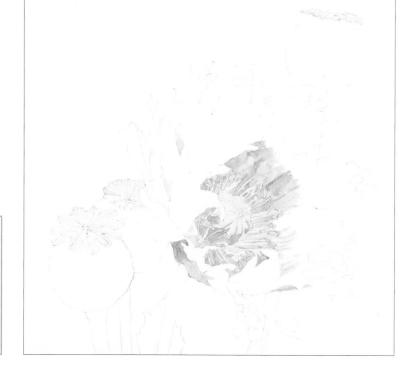

Stigma disc highlight mixes

Watery Winsor lemon with a touch of Winsor green (yellow shade)

Milky Winsor lemon with hints of olive green and Payne's gray

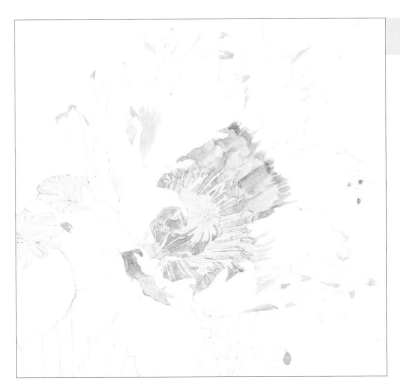

Petals, leaf and seed heads stages 1 and 2 – Highlights and isolating the highlights

7 Use both petal tip mixes to pick out the hues at the tips of the petals and at the transition from the dark parts of the petal to the red parts. Use the tip of the size 0 brush to create hard line edges as you apply the paint. Apply the purple mix to a couple of the darkest parts of the petals.

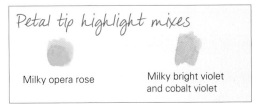

Petal tip highlight mixes

Milky opera rose

Milky bright violet and cobalt violet

8 Create a milky mix of scarlet lake with hints of translucent orange to match the lightest tones on the right-hand petals. Apply it as a wash, using a size 3 brush to cover larger areas, and swapping to a size 0 brush towards the edges, where more control is required. Apply the wash within the boundaries of your pencil marks even where petals meet one another, rather than working the wash over those pencil marks. This way if you get overlaps along the pencil marks, you further define those edges to the petals, enabling you to see the shapes more clearly. Take this wash over the areas of purple applied to the red parts of the petal in the previous step (which will be dry).

Note

There are plenty of potentially unwanted hard line edges or overlaps where I have been applying the paint. These will naturally be covered up in subsequent layers, so do not worry about them at this stage.

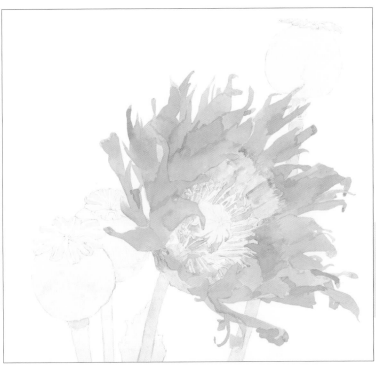

9 Thoroughly clean your brush from the previous mix; make sure that the petals are totally dry and then apply a very watery mix of Payne's gray, permanent sap green and cobalt turquoise light to the seed heads, the left two stems and the leaf. Use a size 3 brush to apply the wash, making use of the tip to create crisp edges within your pencil lines.

10 Apply a watery mix of Winsor lemon and a touch of Payne's gray to the two stems on the right-hand side and the strip under the leftmost seed head. Again, use the size 3 brush to apply the wash, using the tip to ensure you stay within the pencil boundaries.

Petals, leaf and seed heads highlight mixes

Milky scarlet lake with hints of translucent orange

Very watery Payne's gray, permanent sap green and cobalt turquoise light

Watery Winsor lemon and a touch of Payne's gray

Petals stage 3 – Darkest tones

11 Use a 000 brush to carefully fill in the gaps in the petals around the upper stamens with the darkest petal mix.

12 Swap to a size 1 brush to extend this coverage out using a hard line brush technique to the edge of the dark area, leaving little gaps where the hue is lighter. Apply this in the same way at the bottom of the flower.

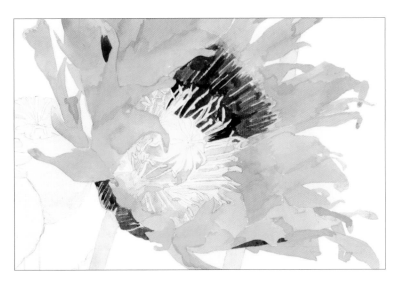

Petal darkest mix

 Bright violet with Payne's gray and burnt sienna at a consistency between cream and butter

Petals stage 4 – Midtones and contrast

13 Concentrating on the next darkest tones within the red parts of the petals, apply the first midtone mix to the darkest parts of the red hue areas using a size 1 brush, recreating the line markings by making hard line edges and applying the paint in the direction of growth of the petals.

Red petal first midtone mix

 Permanent carmine and bright violet at a consistency between milk and cream

Note

This mix is a little more purple than you might expect, because we will be applying more of the orange mix on top of it. This will result in hue mixing through layering taking place, resulting in an accurate finished picture.

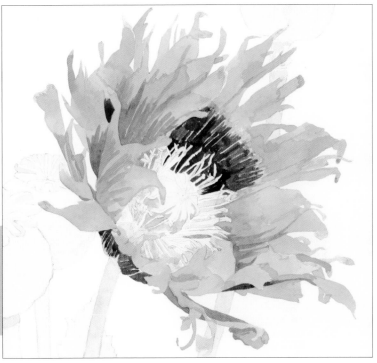

14 Apply the second midtone mix as a wash with a size 1 brush over the now dry paint applied in step 13 and everywhere that tone or darker. Vary the ratios of the two hues within the ranges shown below. Always apply the paint in the direction of growth of the petals.

Red petal second midtone mix

 Milky scarlet lake and translucent orange at a milky consistency.

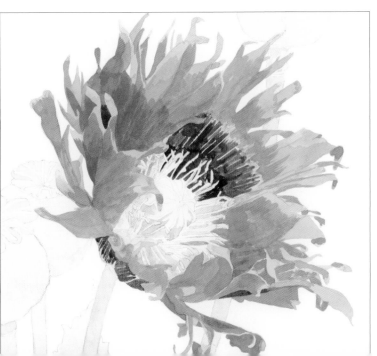

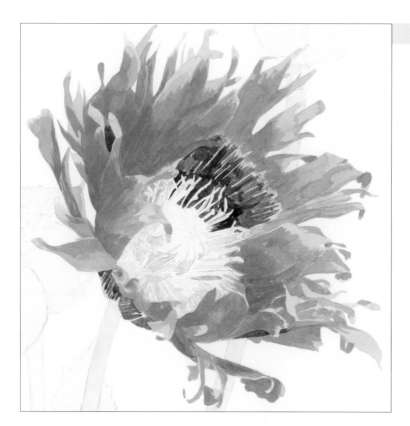

Petals stage 4 continued – Midtones and contrast

Once the previous layer is dry, we can begin refining the midtones on the petals with further layers and darker tones to get the contrast levels to look correct.

15 Apply a further layer of the second red midtone mix, beginning in the darkest areas of the petals to darken them further. As you darken the darkest area, you will see areas further out on the lighter parts of the petals where you can also apply this wash. Vary the proportions of the hues within the range shown below.

Red petal second midtone mix

Milky scarlet lake and translucent orange at a milky consistency.

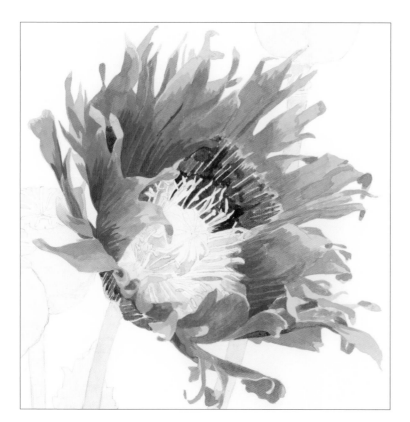

16 Use a 0 brush to apply the third midtone mix where you see this darker tone. Apply using a hard line brush technique to create the visible lines. This helps to create the shape of the petals.

Red petal third midtone mix

Scarlet lake and bright violet at a consistency between milk and cream

17 Using the second midtone mix, focus on bridging the gap between the last two layers. Use a size 1 brush and take care to use this layer to create graduated edges where required to the transitions between the mix applied in step 16 and this new layer. Use a size 000 brush when applying this mix to the very edges of the petals.

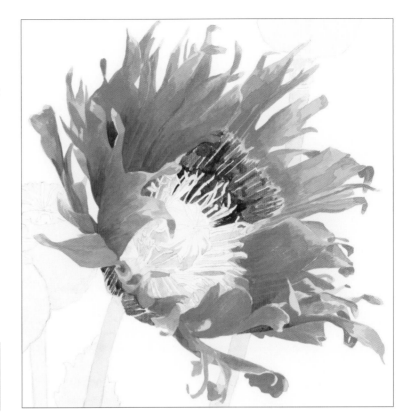

Red petal second midtone mix

Milky scarlet lake and translucent orange at a milky consistency.

Petals stage 4 continued – Midtones and contrast

We now turn to the darkest purple-brown parts of the petals once more. By taking the lightest tones within these dark areas darker it will become possible to assess the contrast and gradually adjust the petals to the correct tone.

18 Focus on the light tones within the darkest part of the petal. On the top petal apply a milky mix of permanent alizarin crimson with hints of Payne's gray as a wash across the whole of the dark area. Use a size 1 brush and change to a size 000 brush for between the stamens.

19 On the lower right area of the flower, between the stamens, use a milky wash of permanent alizarin crimson, Payne's gray and burnt sienna. Again use the size 000 brush to carefully work between the stamens.

20 On the bottom left dark area, apply a milky wash of alizarin crimson and Payne's gray using a size 1 brush.

Petal dark mixes

Milky permanent alizarin crimson with hints of Payne's gray

Milky permanent alizarin crimson, Payne's gray and burnt sienna

Milky alizarin crimson and Payne's gray

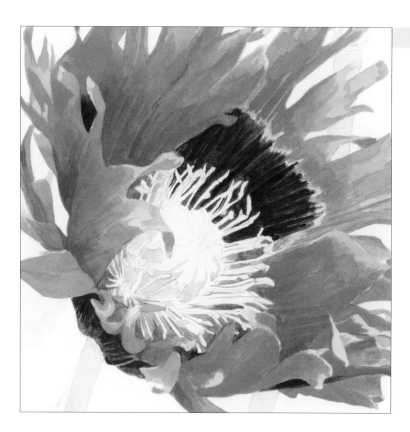

Petals stage 4 continued – Midtones and contrast

21 Apply the petal darkest mix using a size 000 brush to the areas which need it, taking this as a further opportunity to make sure any stripes you see are painted.

Petal darkest mix

Bright violet with Payne's gray and burnt sienna at a consistency between cream and butter

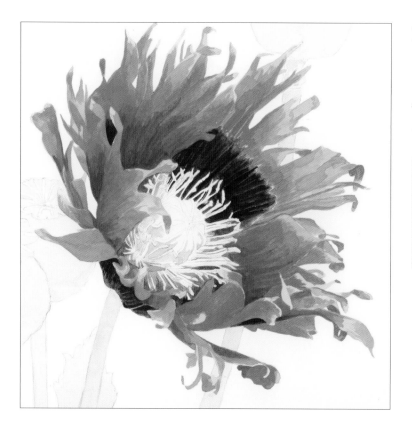

22 Use a size 0 brush to apply the mix of permanent alizarin crimson with hints of Payne's gray to the same areas you worked on in step 16 (see page 106).

23 Use creamy bright violet to pick out the darker purple parts on the transition line between the dark and red parts of the petals.

Petal additional midtone mixes

 Permanent alizarin crimson with hints of Payne's gray at a consistency between milk and cream

 Creamy bright violet

Stigma disc stage 4 – Midtones and contrast

It is at this point in the painting that you are rewarded for accuracy in your drawing. As you develop the stigma disc, work with your drawing to create the shapes you see there.

24 Use a size 000 brush to work on the midtones in the stigma disc, applying milky Winsor lemon mixed with varying amounts of permanent sap green and adding in Payne's gray where necessary. As always, allow the area to dry before continuing.

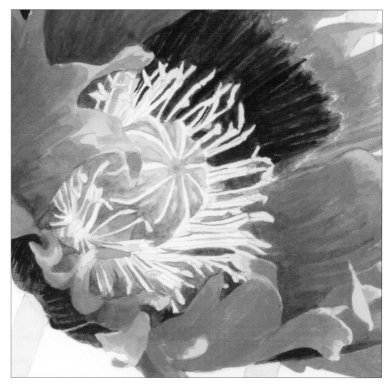

Stigma disc midtone mixes

Milky Winsor lemon with permanent sap green

Milky Winsor lemon with permanent sap green and hints of Payne's gray

Stamens stage 4 – Midtones and contrast

While working on the stamens, start at the base and work outwards so that you naturally run out of paint, and apply less towards the ends. This allows the ends to stay lighter in tone. As you darken the stamens it will become apparent that the base of the stigma disc needs to be darker.

25 Apply a wash of bright violet and Davy's gray, between water and milk in consistency, to the stamens with a size 000 brush. Add in burnt sienna where necessary.

26 Once dry, create lines between the stamens using the same brush to go over your pencil marks with a mix of bright violet and Payne's gray at a consistency between milk and cream.

27 Create a milky mix of permanent sap green with hints of Payne's gray and apply it between the stamens at the bottom left side of the stigma disc with a size 000 brush.

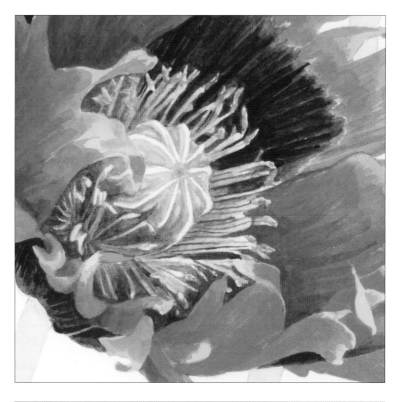

Note

Clean your brushes and your Payne's gray pan thoroughly at this stage to make sure any trace of red hues is gone before you continue.

Stamen midtone mixes

 Bright violet with Davy's gray at a consistency between water and milk

 Bright violet with Davy's gray and burnt sienna at a consistency between water and milk

 Bright violet and Payne's gray at a consistency between milk and cream

Milky permanent sap green with hints of Payne's gray

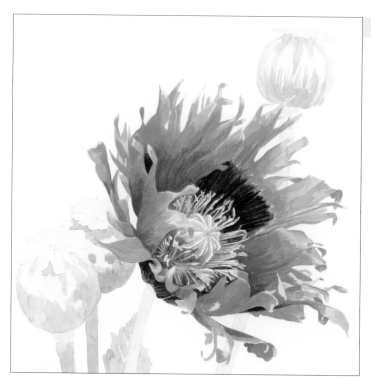

Seed heads, stems and leaf stage 4 – Midtones and contrast

You will notice that we do not work through stage 3 (darkest tones) for the seed heads, stems and leaf areas. The reason for this is that we already have the darkest tones of the flower in place on the paper which serve as a great visual anchor point for assessing contrast. Instead, we gradually build up to the darkest tones in the seed heads, stems and leaf through stage 4 now.

The tone and hue variation is subtle on the seed heads and there are graduated edges between the shadows at the tops and bottoms of the seed heads and the lighter strips in the centres. So for this we need to try to create graduated edges as we apply the mix.

28 Use a size 1 brush to apply a mix of Payne's gray, permanent sap green and olive green at a consistency between water and milk to the seed heads, left two stems and leaf. Begin on the darkest areas and apply the mix only to the parts that are the tone with which you are working or darker.

29 Water the green mix down and add in some cobalt violet. Use a size 0 brush to apply this mix to the top of the upper seed head.

Note

Make sure you leave the veins on the leaf and be careful as you apply next to the red petals. Even though they will be dry, you do not want them to overlap as this mix will show up very dark on the red.

Green midtone mixes

Payne's gray, permanent sap green and olive green at a consistency between water and milk

Watery Payne's gray, permanent sap green, olive green and cobalt violet

Milky Payne's gray, olive green and cobalt turquoise light

Permanent sap green and olive green with hints of Payne's gray at a consistency between milk and cream

30 Create a mix of Payne's gray, olive green and cobalt turquoise light in a milky consistency. Apply a wash of this mix over the darkest areas again to darken them further. Then water the mix down a little and take it over the lightest areas of the seed heads.

Note

We need to work with quite watery layers on these seed heads in order to achieve the graduated edges we see there. In this particular case the seed heads need only be about eighty per cent dry before you apply the next layer because a little bit of bleeding as you apply the layers will help to create the graduated edges.

31 Create a mix of permanent sap green and olive green with hints of Payne's gray at a consistency between milk and cream. Use a size 000 brush to pick out details on the seed heads and stems.

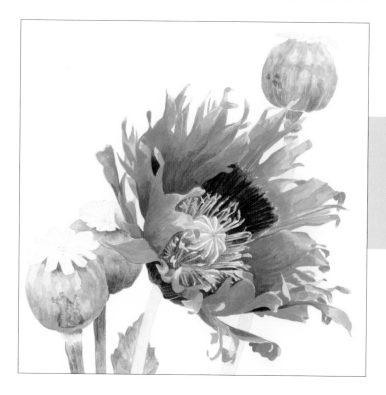

Seed head stigma discs stage 4 – Midtones and contrast

Now the tone on the seed heads has been built up we can tackle the details on the darkest parts of the seed heads: the stigma discs.

32 Use a size 000 brush with milky mixes of Payne's gray and burnt sienna to pick out the details in the dark stripes. Vary the proportions of the paints in the mix as you work.

33 Still using the size 000 brush, apply a mix of olive green and permanent sap green with hints of Payne's gray around the dark stripes as shown. Keep the paint at a consistency between milk and cream.

34 Use a mix of Winsor lemon with hints of olive green at a consistency between milk and cream to pick out the darker yellow on the stigma discs.

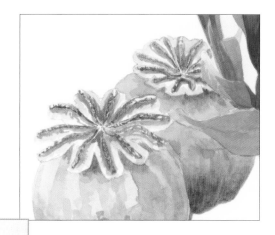

Stigma disc midtone mixes

Milky Payne's gray and burnt sienna at varying ratios within this range	Olive green and permanent sap green with hints of Payne's gray at a consistency between milk and cream	Winsor lemon with hints of olive green at a consistency between milk and cream

Seed head stigma discs stage 4 continued – Midtones and contrast

35 Use the mix and techniques from step 32 to detail under the top seed head, then change to a size 000 brush and apply a layer of a creamy mix of Payne's gray and burnt sienna to the stripes where the tone needs to be darker.

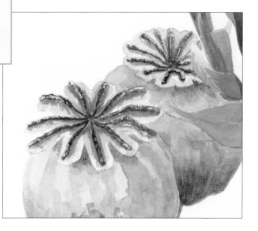

Seed heads, leaf and stems stage 4 continued – Midtones and contrast

With the overall stigma discs darkened, it becomes clear that the darkest parts need to be taken darker.

36 Use the size 000 brush to apply a milky mix of olive green, Winsor lemon with hints of Payne's gray in lines up and down the two rightmost stems. Create several layers where the tone is darker. Apply the paint in lines to help ensure you capture the visual texture present on the stems.

37 Use size 0 and 000 brushes to apply another mix of Payne's gray, permanent sap green and olive green, at a consistency between water and milk, to any parts of the stems, leaf or seed heads that need to be darker. Be careful to leave a paler outline around the stem as you work on the leaf.

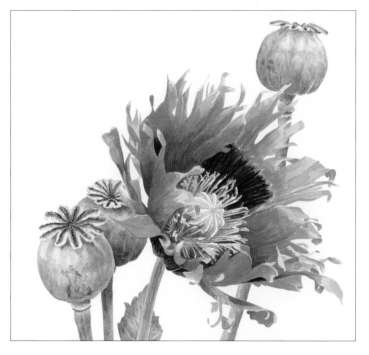

Seed heads, leaf and stem midtone mixes

 Milky olive green, Winsor lemon with hints of Payne's gray

 Payne's gray, permanent sap green and olive green at a consistency between water and milk

Milky scarlet lake with hints of translucent orange

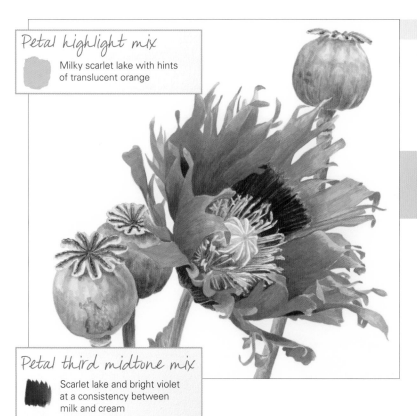

Petal third midtone mix

Scarlet lake and bright violet at a consistency between milk and cream

Whole composition stage 5 – Reassessing highlights and hues

With the midtones built up in every hue area, we can assess the highlights again and, in my case here I need to take them a little darker to get the contrast levels right. You may not need to if your initial highlight washes were darker than mine.

Note

Ensure your brushes are clean as you switch back to working on the red hues.

38 Apply the petal highlight mix as a wash over the areas of highlight that need to be darker using size 0 and 000 brushes. Use neat opera rose at a milky consistency to darken the pink tips where necessary.

39 Create a mix of scarlet lake and bright violet at a consistency between milk and cream and apply with a 0 brush to any darker midtones that need to be darker still.

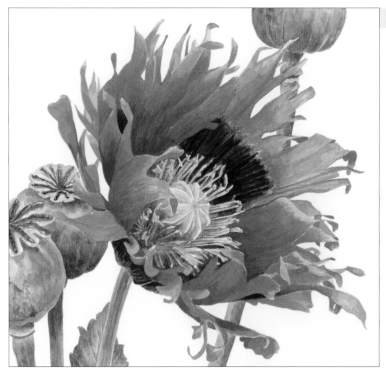

Final mixes

Watery Winsor lemon with hints of permanent sap green

Watery bright violet and Davy's gray

Whole composition stages 5 and 6 – Reassessing highlights and hues, and details

At this point, instead of knowing when to stop, you actually need to know when to carry on with this realistic style of working! Take a step back, literally, and observe your painting compared to the reference image. Can you see any areas which need to be taken darker to get the contrast levels to look correct? My painting needed some additional darkening of quite a few areas.

40 Create a watery mix of Winsor lemon with hints of permanent sap green. Apply with a size 000 brush over the yellow highlights.

41 Create a watery mix of bright violet and Davy's gray. Apply a wash with a size 000 brush over any highlights on the stamens which need to be a little darker.

42 The areas that need darkening will be specific to your own painting but may include the darkest parts of the petal, especially where they meet the stems. Use the same darker mixes already used on those areas and make sure that your paint is dark enough to match the tone you are creating.

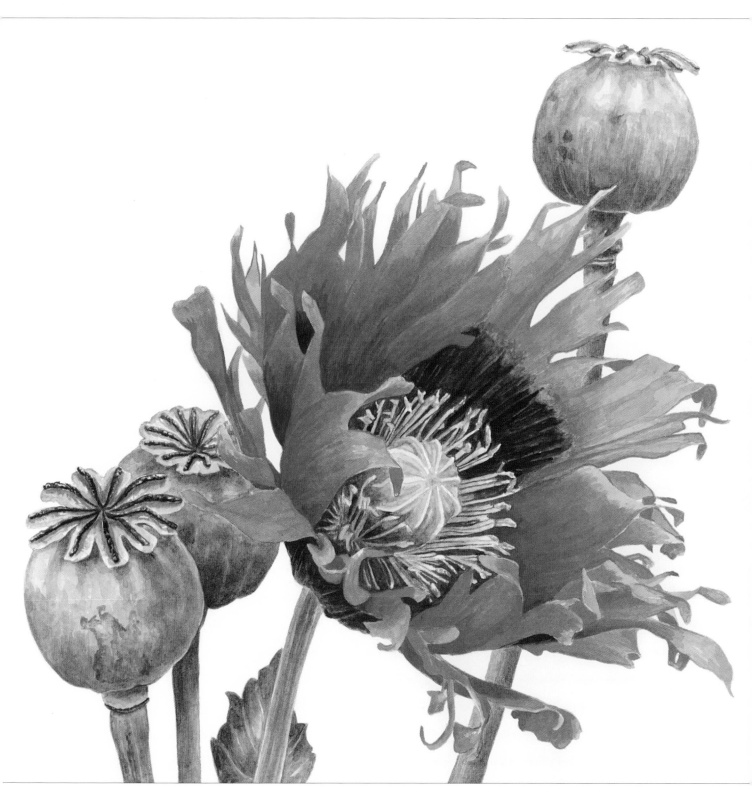

The finished painting

The feathered edges of these petals make us believe that the flower could be quivering in the summer breeze. That sense of movement is achieved by subtle variations in tone, and to a lesser extent, hue.

Dahlia

This glistening dahlia, 'Twyning's Smartie', is quite a challenge and I am including it for you to stretch yourself, and also for you to see that the seemingly different elements in it – the complex centre, the white petals, the vein-covered leaf and especially those rather magical reflective water droplets – are all tackled in the exact same way as the other paintings in this book, using the same six stages of painting. It should take you between ten and fifteen hours over two or three days.

The areas of greatest contrast are where the dark, velvety base of the petals meets the light, bright yellow of the stamens, and where the dark green of the leaves meets the white petals.

As usual, each different hue area must be tackled independently, but the painting must also be considered as a whole when assessing hue and, crucially, tone. With this dahlia, I decided to bring my petals and the yellow centre through stages 1–4 of the process before I tackled the leaves and stem. You can choose to tackle these three hue areas in any order, or indeed simultaneously – i.e. work on stage 1 for each hue area, then stage 2 for each hue area etc. The key thing is that you can not really complete stage 4 or move on to stages 5 or 6 for any hue area until you have brought them all on to stage 4. This is because you need to see how the painting looks as a whole in order to assess how dark your darkest areas need to be.

This greyscale version of the finished artwork shows us just how dark the leaf needs to be as well as how dark the petals are towards the centre of the flower. If you look closely, you can also see the tonal variation present in the water droplets.

Tonal image

You will need

Watercolour paper: 300gsm (140lb), white, Hot Pressed finish, 25.5 x 18cm (10 x 7in)

Watercolour paints: Davy's gray, cobalt violet, Winsor lemon, yellow ochre, opera rose, bright violet, quinacridone red, permanent alizarin crimson, Payne's gray, permanent carmine, quinacridone magenta, burnt sienna, translucent orange, olive green, permanent sap green, Winsor blue (green shade)

Paintbrushes: size 3, size 1, size 0, size 000

Pencil, eraser

Drawing

On a flower with such a complicated centre it is really important to draw all of that detail before you start painting. Getting this right really makes a difference in the piece's realism.

On the dark pink petals I have drawn out the outline edge of the water droplets. That is because I am confident that around those droplets I will be building up the paint so dark that you will not end up seeing the pencil marks. This is not the case on the white petals where the paint will be so watery and light that pencil could well be seen. I have therefore not drawn in the droplets there and will paint them in with my very first wash.

1 Following the instructions on pages 24–25, lightly reproduce the outline on page 127 on your watercolour paper.

Painting

White petals stage 1 – Highlights

Start with the lightest area of the composition, the white petals. The highlights here are so light (as you will always find with white flowers) that we leave them with no paint on them at all.

2 Use a size 1 brush to apply the white petal highlight mix everywhere except the lightest parts, including the droplets which, as noted opposite, were not drawn in.

white petal highlight mix

Very watery Davy's gray with hints of cobalt violet

White petals stage 2 – Isolating highlights

The initial wash is so subtle that, to isolate the highlights further and to be able to see them, go straight in with a second layer of the same mix. The tonal differences you make here should already create a sense of three-dimensionality.

3 Once the first layer is dry, use a size 000 brush to apply another layer of the white petal highlight mix, focussing on the darkest areas of the white petals (which include the darkest parts of the droplets).

Flower centre stages 1 and 2 – Highlights

4 Use a size 1 brush to apply the flower centre highlight mix over the centre of the flower and into the base of the bottom white petal.

5 Isolate the highlights within this hue area by applying a second layer of the mix to everywhere in the centre except the highlights.

Flower centre highlight mix

Very watery Winsor lemon with hints of yellow ochre

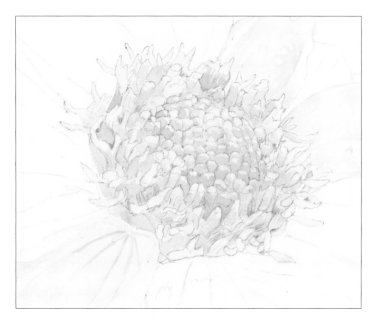

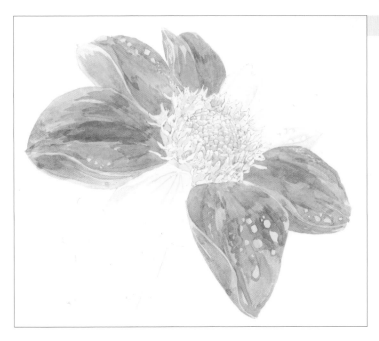

Pink petals stages 1 and 2 – Highlights

Turning to the pink petals, look to match the lightest colour within them. Apply the paint from the centre of the flower out towards the tips of the petals.

6 Make a watery wash of opera rose and bright violet. This mix should be lighter than the lightest highlight within the droplets on these petals. This means it can be taken all over the petals with a size 3 brush – including over the droplets.

7 Once dry, apply a second layer of this mix, taking it to a milky consistency and adding in some milky quinacridone red where required. Apply the second layer everywhere except for the droplets and any highlights at the edge of the petals. Be sure to use the tip of the size 3 brush, or even a smaller brush, when you are creating neat hard line edges around the droplets.

Note

Note how streaky the brushwork is at this stage. There are lots of hard line edges where I will not want them in the finished painting. This is not a problem because these petals will be taken a lot darker later. Once we have further layers of paint on top we are not likely to see them; and if any do remain visible, the fact that we have applied the paint in the direction of growth of the petals (see page 52) means those marks will work to our advantage and provide shape.

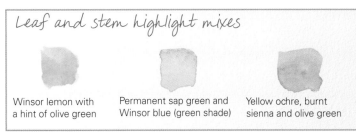

Pink petal highlight mixes

Opera rose and bright violet at a consistency between water and milk	Milky quinacridone red

Leaf and stem stages 1 and 2 – Highlights

For the leaf, look to match the lightest hue within the leaf – that of the veins.

8 Use a size 3 brush to apply a milky wash of Winsor lemon with a hint of olive green over the main leaf, and to the veins on the sepals, which have the appearance of smaller leaves.

9 The sepals have a highlight to them as well as their vein colour, so use a size 1 brush to apply a very watery wash of permanent sap green and Winsor blue (green shade) and match that highlight.

10 Apply a watery wash of yellow ochre, burnt sienna and olive green to establish the stem with a size 1 brush.

Note

I was so keen to get on with the petals I actually forgot to lay down a highlight wash on my leaves at this early stage, and I ended up doing it after I had worked on stage 4 of the petals.

It does not really matter what order you tackle each hue area in. However, I suggest you do get a wash down on all hue areas straight away so that you are not having to apply one next to dark, thicker paint which may be more likely to bleed into a watery wash.

Leaf and stem highlight mixes

Winsor lemon with a hint of olive green	Permanent sap green and Winsor blue (green shade)	Yellow ochre, burnt sienna and olive green

Pink petals stage 3 – Darkest tones

The darkest area of the petals, and of the whole composition, is the velvety, almost black, markings at the base of the petals.

11 Apply the pink petal dark mix to the areas shown using a size 0 brush. Use some stippling here to recreate the rough visual texture to these marks, but be careful to use the tip of your brush to create the hard line edges around the stamens.

Pink petal dark mix

Creamy permanent alizarin crimson and Payne's gray

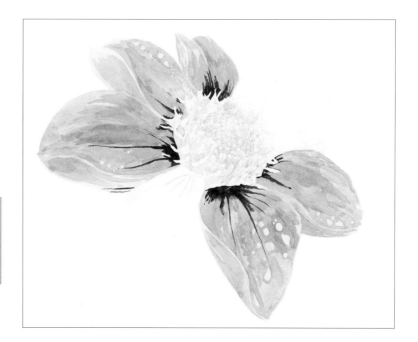

Pink petals stage 4 – Midtones

The visual texture of the pink petals is fairly smooth, but note the lines coming out from the centre of the petals to their tips. We want to create these with our brushstrokes.

With the darker mixes, be cautious and apply this mix only where you are certain the tone is this dark.

12 Use the pink petal midtone mixes shown and apply each one where you see those hues using a size 3 brush. Begin with the next darkest tones by using the mix of permanent alizarin crimson, Payne's gray and burnt sienna at a consistency between milk and cream.

13 Next, focus on the lighter midtones using a milky mix of opera rose and bright violet, applying the paint with the size 3 brush.

14 Still using the size 3 brush, begin to bridge the gap between the darker and lighter midtones by using a milky mix of permanent carmine and quinacridone magenta on the next darkest midtones.

15 Continue bridging the gap between tones with milky mixes of opera rose with hints of permanent alizarin crimson and Payne's gray on the next lightest tonal areas. Vary the proportion of each colour within the range shown.

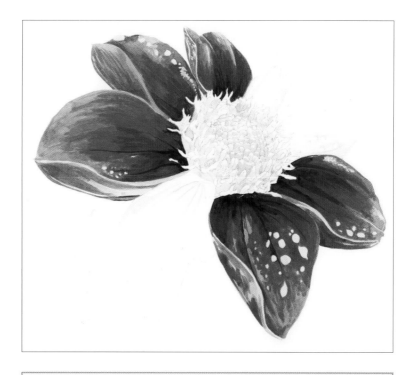

Pink petal midtone mixes

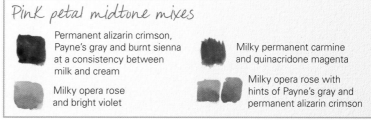

Permanent alizarin crimson, Payne's gray and burnt sienna at a consistency between milk and cream

Milky permanent carmine and quinacridone magenta

Milky opera rose and bright violet

Milky opera rose with hints of Payne's gray and permanent alizarin crimson

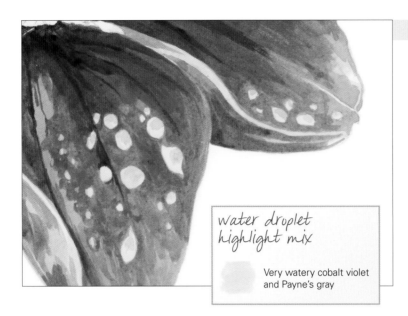

Water droplets stage 3 – Darkest tones

Now that the petals are much darker, it is easier to see that the highlights on the droplets need to be darker. As you apply the wash, do not take it over the whole of the droplets or you risk not being able to clearly identify the highlights within them.

16 Mix cobalt violet with a tiny amount of Payne's gray at a very watery consistency, then use a size 000 brush to place the paint on the highlights.

water droplet highlight mix

Very watery cobalt violet and Payne's gray

Note

Make this assessment of contrast on your own painting for yourself. If your initial wash on the petals was darker than my one here you may not need to darken the highlights on your droplets at all.

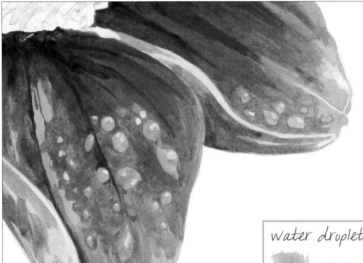

Water droplets stages 3 and 4 – Darks and midtones

17 Use the water droplet dark and midtone mix (this is essentially a paler version of the petal colour) to match the colour of the midtones within the droplets. Apply the paint using a size 000 brush, making sure you leave the highlights clean.

18 Once dry, use the exact same mix again to apply a further layer to those parts of the droplets that need it – the dark tones within the droplets. Again, use a size 000 brush and be careful that the paper is dry before you apply it so that there is no danger of the paint spreading into the highlight areas.

water droplet dark and midtone mix

Milky opera rose with hints of bright violet and quinacridone red

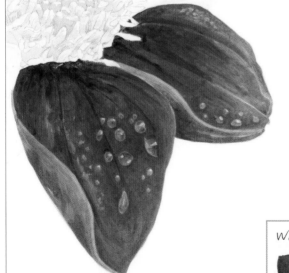

Pink petals stage 4 continued – Midtones and contrast

Once the paint on the droplets has dried, you need to make a judgement on whether the rest of the petals should be darkened further.

19 If necessary, use a size 3 brush to darken up the rest of the petal using either thicker, darker versions of the pink petal midtone mixes (see page 117) or a creamy combination of permanent carmine and bright violet.

20 You can darken the underside of the petals with a mix of quinacridone magenta and Payne's gray if necessary. Then, using a size 000 brush, darken parts of the droplets again until the contrast levels seem right.

water droplet dark and midtone mixes

Creamy permanent carmine and bright violet

Milky quinacridone magenta and Payne's gray

Flower centre stage 3 – Darks

Once all the pink petals have been worked upon, you can turn your attention to the flower centre with the dark tones of the petals in place for guidance. This bit requires serious concentration and will be much easier if you have an accurate drawing.

21 Create a milky mix of yellow ochre, burnt sienna and Payne's gray. Use a size 000 brush to apply the mix carefully to the darkest parts of the flower centre. Vary the proportions of the colours and also the consistency of the paint to more creamy, in order to match the tone of the parts on which you are working.

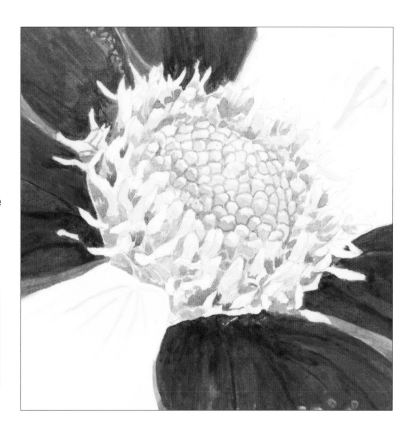

Stamens dark mixes

 Yellow ochre, burnt sienna and hints of Payne's gray between milk and cream in consistency

Flower centre stage 4 – Midtones

22 Once the darks are in place, use the hue mixes below to work on the midtones and then on the dark areas again. All of this is done with a size 000 brush and the paper needs to be really dry between layers so that you can keep clean, defined hard line edges where they are needed.

Note

Remember, it is best to create and use one mix at a time. If you create them all in advance, they may dry out before you use them.

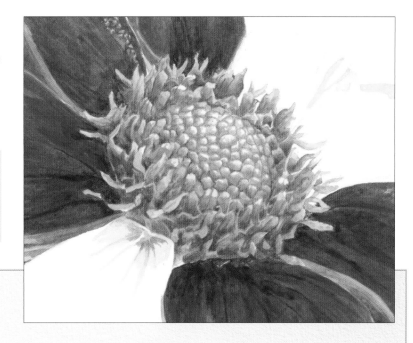

Flower centre midtone mixes

 Translucent orange with varying amounts of Winsor lemon, at consistencies between milk and cream

 Yellow ochre with varying small amounts of Payne's gray, at consistencies between milk and cream

 Creamy Winsor lemon, yellow ochre and hints of burnt sienna

Creamy Winsor lemon, Davy's gray and hints of burnt sienna

 Creamy burnt sienna and permanent alizarin crimson

 Creamy burnt sienna and Payne's gray

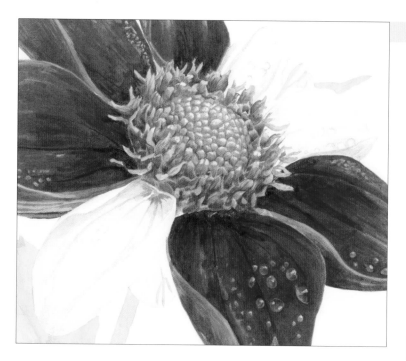

White petals stages 3 and 4 – Darks and midtones

Now that the centre is sufficiently dark, it makes it easier to see that the white petals need to be darker.

Throughout these steps, be especially careful as you get close to any of the pink petals so that you do not accidentally touch them with your brush and cause the pink paint to bleed into the pale wash you are applying.

23 Apply the white petal midtone mix to the darkest parts of the white petals with a size 3 brush to give them subtle blue-grey shading.

24 Use a size 000 brush to apply the same colour around and on the dark parts of the droplets on the white petals.

white petal midtone mix

Watery cobalt violet and Payne's gray

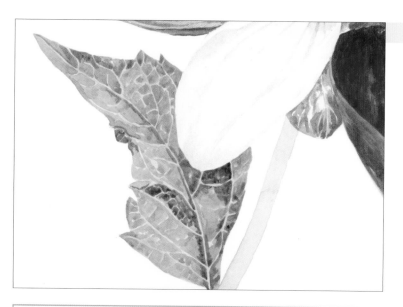

Leaves and stems stages 3 and 4 – Darkest tones and midtones

The petals and centre are now fairly complete but until we have the leaves and stem as dark as they should be it will not be possible to judge whether our petals and centre should be darker still.

Here we need to block in the main colour on the leaves, while leaving the highlights – crucially the veins.

25 Apply a milky mix of olive green and permanent sap green to the leaf using a size 1 brush. The visual texture of the leaf is fairly smooth so you can apply the paint as a wash. The veins are lighter in tone, so leave gaps for them as you apply this mix, in order to create hard line edges around them. The veins are also lighter in tone than the pencil lines we used to define the main veins, so along the main veins, create the gaps to one side or the other of the pencil line.

26 Once dry, add a little Payne's gray to thicken the mix a little and darken the hue. Still using the size 1 brush, focus on the darkest tones with this mix.

Leaf midtone and dark mixes

 Milky olive green and permanent sap green

 Olive green, permanent sap green and a touch of Payne's gray at a consistency between milk and cream

Note

You do not need to get every vein in exactly the right place, but having the angles of the main ones correct does help to create shape.

Leaves stage 4 continued – Midtones

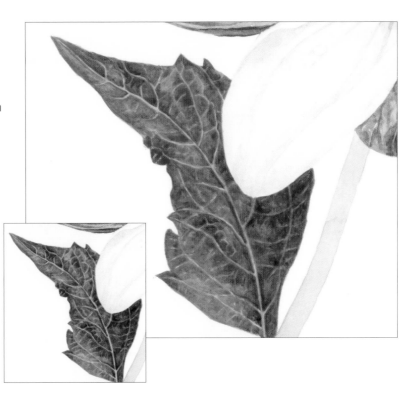

27 Use the leaf midtone and dark mixes to gradually bridge the gap between the light midtones and the dark midtones. When the leaves start to look dark enough the veins will start to stand out too much as being too light (see inset).

28 To make the veins darker, use the wash technique with a size 3 brush to gently apply a wash of the leaf vein mix over the whole leaf, including the veins. If you do this gently, the paint will not lift off too much underneath.

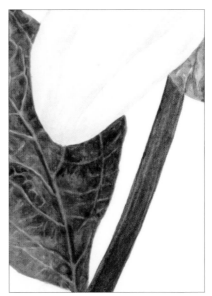

Leaf midtone and dark mixes

 Milky olive green and permanent sap green

 Olive green, permanent sap green and a touch of Payne's gray at a consistency between milk and cream

Leaf vein mix

 Milky Winsor lemon with a touch of permanent sap green

Stems stages 3 and 4 – Darkest tones and midtones

The only part of the portrait still to be darkened is the stem, and as the stem is very dark, this will affect our perception of the tonal balance of the whole portrait.

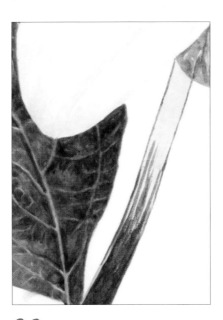

Stem dark and midtone mixes

 Creamy permanent alizarin crimson, burnt sienna and Payne's gray

 Milky permanent alizarin crimson, burnt sienna and Payne's gray in different ratios

29 Use a creamy mix of permanent alizarin crimson, burnt sienna and Payne's gray and a size 0 brush to apply the paint in lines up the stem, creating an outline to the stem and also picking out the darkest part at the bottom.

30 Use the same dark mix but dilute it to a watery/milky consistency and vary the ratios of Payne's gray and permanent alizarin crimson to create hue variation within the stem. Apply the mix as a wash using a size 0 brush in lines working up or down the stem. Use several layers if required for the correct depth of tone. Also apply a layer of this mix over the lower part of the leaf vein to alter the hue there.

Stage 5 – Reassess highlights and hues

Now that the leaf and stem are dark enough we can better assess the highlights across the picture as a whole – in this case the white petals. When I reached this point with my painting I realised I needed to take my white petals a little darker, so I used the same midtone mix as earlier.

Once I had darkened these up it was clear that I needed to take the darkest parts of my composition around the base of the petals still darker, and so I added another thick layer of the pink petal dark mix (see page 117).

I also corrected my hue balance by brightening the pink petals with a wash of opera rose with bright violet in a few places as well as some neat quinacridone red in a few others. I also darkened up the underside of petals too.

31 Assess the contrast levels and hue balance in your own painting. Darken the white petals a little if required using the white petal midtone mix, and/or darken the base of the pink petals with the stem dark mix if required.

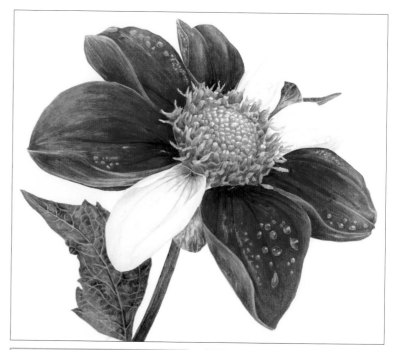

white petal midtone mix

Watery cobalt violet and Payne's gray

Stem dark mix

Creamy permanent alizarin crimson, burnt sienna and Payne's gray

Stage 6 – Details and contrast

Pay attention to the area at the base of the bottom white petal which in my painting needed some of the stem midtone mixes (permanent alizarin crimson, and burnt sienna with different amounts of Payne's gray, all at a milky consistency) to pick it out.

Pay close attention to the areas of greatest contrast and try to ensure you have the balance right to complete your painting.

32 Pick out any details that are required and take the chance to define edges of petals, stamens and leaves so that they are crisp and clear.

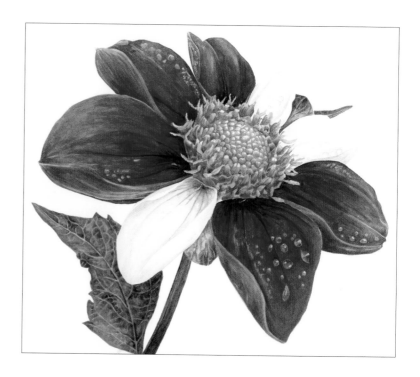

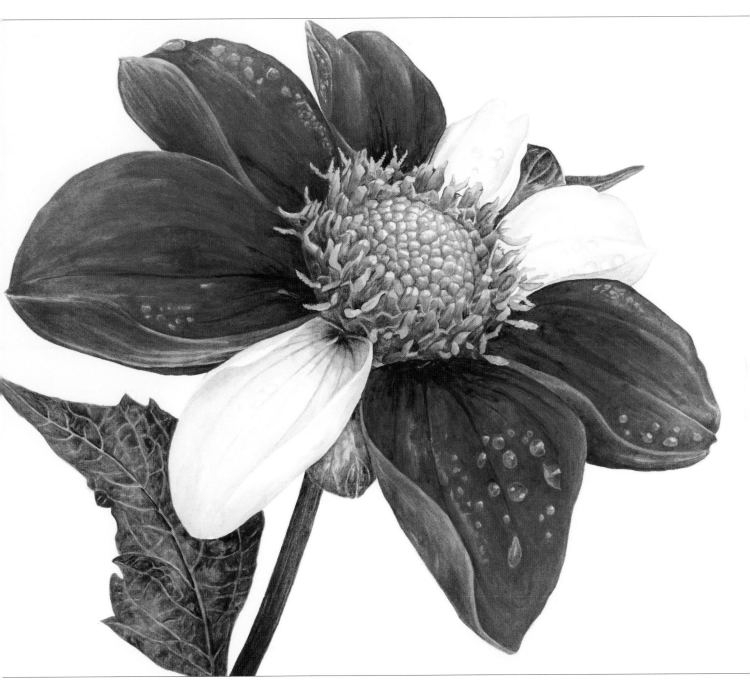

The finished painting

The water droplets really help to give a fresh, realistic look to the flower, and the detailed centre invites a closer look. It is great fun to capture a level of detail that people seldom have the chance to appreciate in everyday life.

Outline drawings

The outline drawings on the following pages are provided for you to transfer on to your paper using the techniques explained on pages 24–25. Unless otherwise noted, the outline drawings are reproduced here at actual size. Those reproduced smaller have information on how to enlarge them on a photocopier or scanner for the size used in the book.

 If you enjoy working at a larger size, I suggest you scale up the last three projects to about twice the size of the paintings in the book provided here. The relevant outline drawings are accompanied by notes on the scale by which they should be enlarged for this approach.

Clematis *(see pages 72–77), at actual size. No enlargement necessary.*

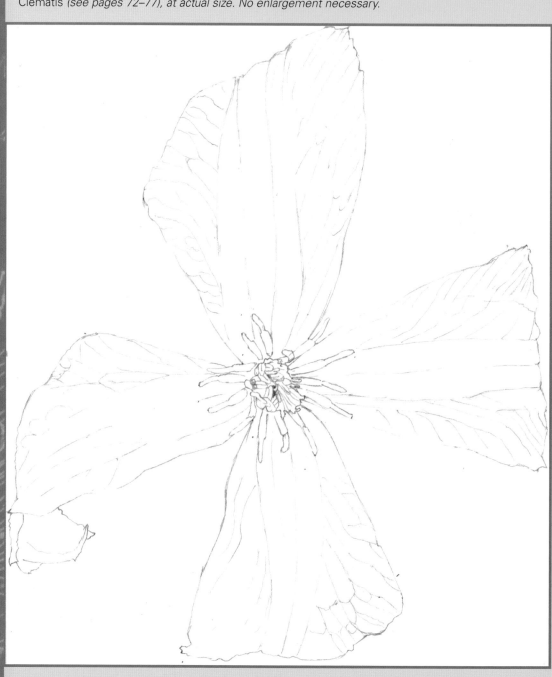

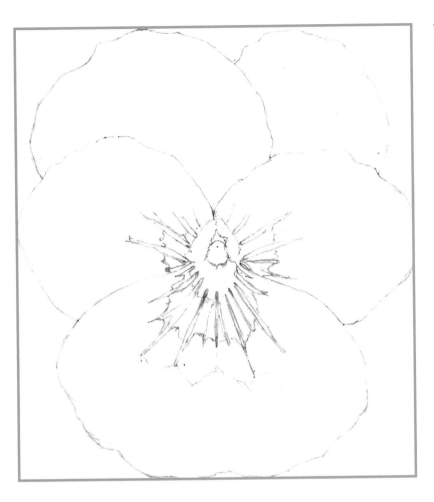

Viola *(see pages 78–85), at actual size. No enlargement necessary.*

Cosmos *(see pages 86–93), at three-quarters of actual size. Enlarge by 133 per cent for the size used in the project.*

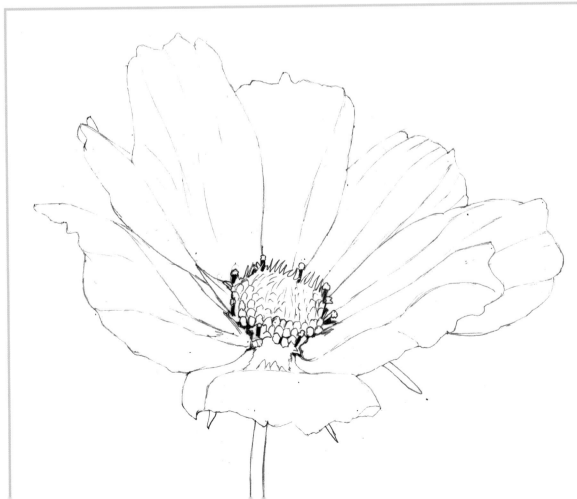

Tulips *(see pages 94–101), at actual size. No enlargement necessary for the size used in the project. Enlarge by 200 per cent for a double size painting.*

Oriental Poppy *(see pages 102–113), at three quarters of actual size. Enlarge by 133 per cent for the size used in the project, or by 266 per cent for a double size painting.*

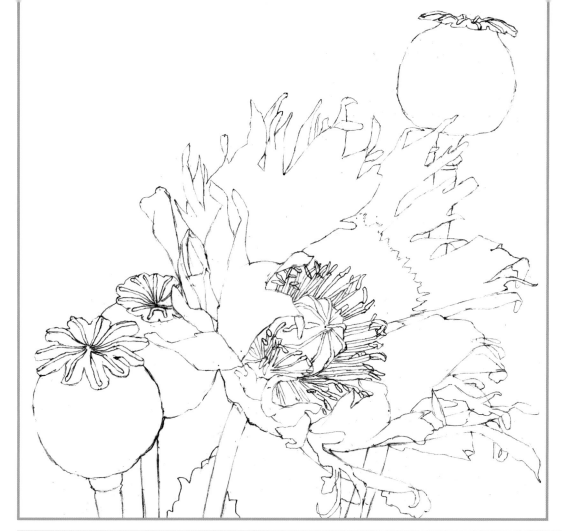

Dahlia *(see pages 114–123), at three-quarters of actual size. Enlarge by 133 per cent for the size used in the project, or by 266 per cent for a double size painting.*

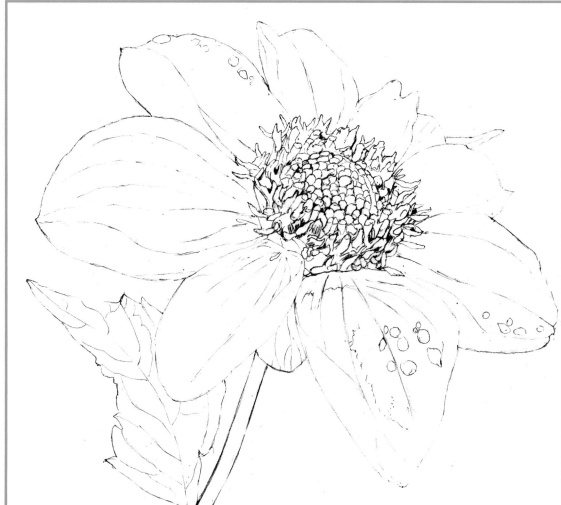

Index

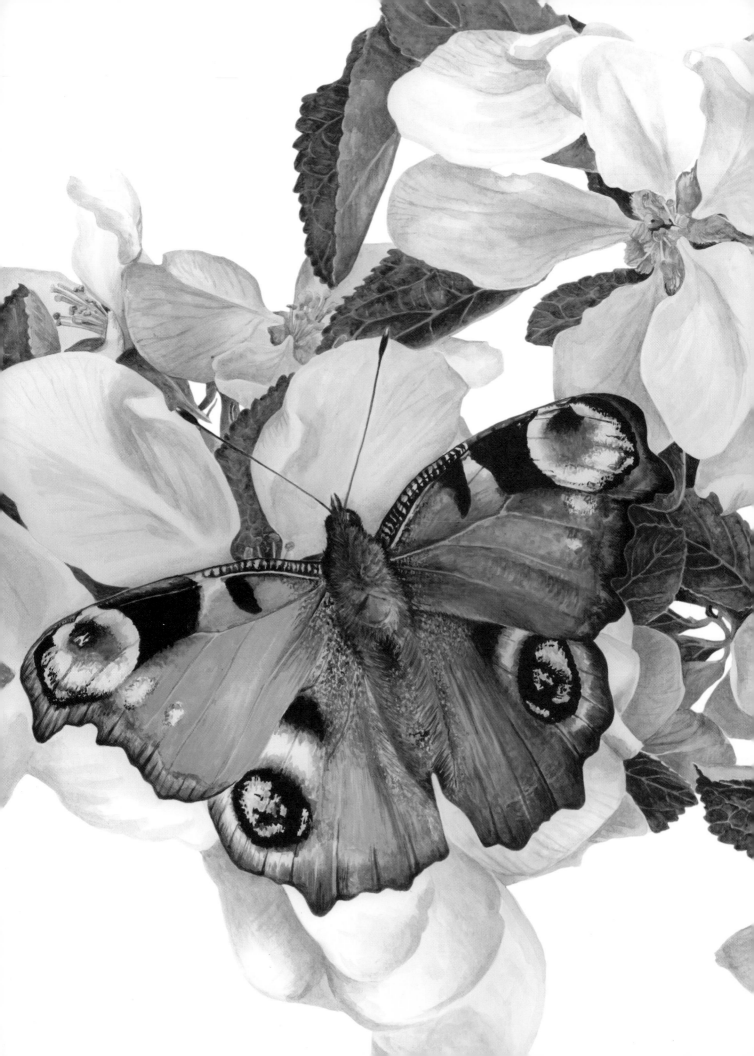